Images of Modern America

WEIR FARM NATIONAL HISTORIC SITE

D1453979

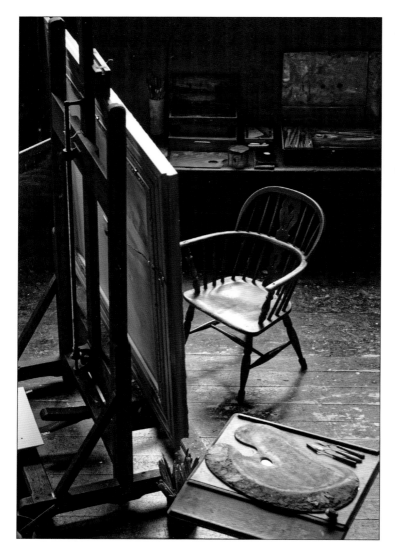

Julian Alden Weir's studio is one of the many highlights at Weir Farm National Historic Site. Visitors can see the original easel, brushes, paints, and palettes that this leader of the American Impressionist movement used to create his masterpieces. (Author's collection.)

FRONT COVER: This view of Julian Alden Weir's studio at Weir Farm National Historic Site features a reproduction of his c. 1905 painting *Upland Pasture*. (Author's collection.)

UPPER BACK COVER: The Weir family poses in front of their house in October 1901. From left to right are (first row) Cora Weir Burlingham, Ella Baker Weir, and Dorothy Weir Young; (second row) Caroline Weir Ely, unidentified, John Ferguson Weir, and Julian Alden Weir. (Weir Farm National Historic Site.)

LOWER BACK COVER (from left to right): This view of sculptor Mahonri Young's studio features a reproduction of his 1937 painting *Harness Races, Danbury Fair*. (Author's collection.) Connecticut musician Saint, like other visitors, draws inspiration from the beauty and peace of Weir Farm. (Author's collection.) Schoolchildren meet Sperry Andrews, the last artist-owner of Weir Farm. (Weir Farm National Historic Site.)

Images of Modern America

WEIR FARM NATIONAL HISTORIC SITE

Xiomáro
Foreword by Sen. Joseph I. Lieberman

ARCADIA
PUBLISHING

ISBN 978-1-4671-0304-6

Published by Arcadia Publishing
Charleston, South Carolina

Printed in the United States of America

Library of Congress Control Number: 2019930753

For all general information, please contact Arcadia Publishing:
Telephone 843-853-2070
Fax 843-853-0044
E-mail sales@arcadiapublishing.com
For customer service and orders:
Toll-Free 1-888-313-2665

Visit us on the Internet at www.arcadiapublishing.com

This book is dedicated to the memory of my daughter and fellow artist Jessica Dieguez, and to my parents, Peter and Lilly Dieguez.

CONTENTS

FOREWORD

It was my privilege to serve the people of the state of Connecticut at the United States Senate from 1989 to 2013.

I am especially proud to have introduced legislation in 1990 to establish Weir Farm in Wilton and Ridgefield as a national historic site. Julian Alden Weir—a leader of the American Impressionist movement of the late 19th and early 20th centuries—lived on the farm, which was an inspiration for his work and for the work of other renowned artists who spent time there. The bipartisan legislation was passed in less than a year, and Connecticut had its first national park when the bill was signed into law by Pres. George H.W. Bush. I remained committed to working with Weir Farm on funding and expansion.

During my final year as a senator, I hosted "the Weir Farm" room dedication and reception in my Washington, DC, office to display the fine art photography of Xiomáro, who was an artist-in-residence at Weir Farm and then went on to become the park's visiting artist. The art exhibited in this room featured his collection documenting the beauty of the interiors of the Weir House, Weir Studio, and the Mahonri Young Studio, which were closed to the public at that time for restoration. I have since had the pleasure of acquiring one of Xiomáro's Weir Farm photographs.

It is fitting that this book by Xiomáro is the first to chronicle Weir Farm's rise from a "little house among the rocks" to a national historic site. Through his artistic photographs, people around the world can and will better appreciate Weir Farm as the only US national park dedicated to American Impressionist painting. And it is only a matter of time before they can also reach into their pockets and find the Weir Farm quarter, which will be issued in 2020 by the US Mint as part of its America the Beautiful series.

Thank you, Xiomáro.

<div align="right">

Joe Lieberman
2018

</div>

ACKNOWLEDGMENTS

The number of people I wish to thank exceeds what I can note here. However, the following—listed alphabetically—directly assisted me over the years, which, in the aggregate, led to the production of this book: Jane Ahern, Tarona Armstrong, Bill Bleyer, Charles Burlingham Jr., Susan Carey, Eleanor Carr, Diane Chisnall-Joy, Pat Clark, Elizabeth Conroy, Linda Cook, Hildegard Cummings, Anne Dawson, Luke DeLalio, Sapna Dhandh-Sharma, Rita Dieguez, Kathleen DiResta, Garrett Eucalitto, Lorin Felter, Ken Grimball, Pat Hegnauer, Janice Hess, Jim Himes, Doris Johnson, Rob Klee, Jessica Kuhnen, Kristin Lessard, Joe Lieberman, Marline Martin, Fletcher McDermott, Kenneth Meadows, Rebecca Migdal, Kevin Monthie, Lina Morielli, Madhuri Pavamani, Michael Pavia, Cara Pavlock, Christiane Ramsey, Clarine Nardi Riddle, Saint, Gerald Siciliano, Megan Smith-Harris, John Sunderland, Dolores Tirri, Peter Trippi, Camille Van Daele, Joris Van Daele, Greg Waters, Mitch Weiss, Cassie Werne, and Heather Whitehouse. Thanks also go to all the television, radio, print, and internet news media, especially in Connecticut, New York, and Utah, that have covered my photography exhibitions; the staff and volunteers of Weir Farm National Historic Site, Weir Farm Art Center, Friends of Weir Farm, and the Wilton Library; all museums, galleries, public spaces, and other exhibition venues that helped bring my photography to the public; and all of my family, friends, colleagues, and social media followers who have purchased and otherwise supported my work. Most importantly, this book would not have been possible without all the experts who produced meticulously researched reports about Weir Farm for the National Park Service.

My relationship with Weir Farm National Historic Site began when I was selected to participate in the artist-in-residence program. This experience developed into a long-term relationship as a visiting artist—the fruits of which can be seen in the photographs illustrating this work. Unless otherwise attributed, images published in this book come from my personal portfolio or from my collections that were commissioned by the National Park Service. Archival historical photographs and other images were provided by Weir Farm National Historic Site (WFNHS). For a free souvenir photographic print (while supplies last), please visit www.xiomaro.com.

INTRODUCTION

Weir Farm National Historic Site has its roots in the conservation and environmental movements of the 1960s. This was the era when the National Park Service was expanding from traditional parks, such as Yellowstone, to include other natural and cultural resources needing protection from rapid commercial development. In the 1970s, subdivisions were threatening the existence of the farm, which had already been reduced to about one-quarter of the original 238 acres that straddled the Connecticut communities of Wilton and Ridgefield. Over time, grassroots efforts resulted in the acquisition of parcels that were set aside for protection. In 1990, Congress established the farm as a national historic site.

Weir Farm thus became Connecticut's first national park and paved the way for the creation of other units in the state such as the New England National Scenic Trail and Coltsville National Historical Park. The communities in Connecticut have also benefited economically. Federal reports show that visitor spending has made steadily rising contributions to an increase in jobs, labor income, and overall economic output.

So what is the historical significance of Weir Farm? Those roots go back even further in time. In 1877, paintings were realistic, detailed, and highly varnished, with few if any visible brushstrokes. That year, a group of young French painters—mockingly called "impressionists" by a critic—revolted against this academic tradition with visible dabs of bright colors to capture the effects of light and time. Julian Alden Weir (1852–1919) saw these painters' 1877 exhibit in Paris while he was studying abroad. Born in West Point, New York, Weir learned the academic style from his father, who taught at the military academy there. Weir's reaction was like others from the conservative art establishment. For him, the exhibition was a "Chamber of Horrors"; he left after 15 minutes with a headache.

In 1880, while in Europe, Weir served as a curator and agent to purchase artwork for the collection of Erwin Davis, a wealthy mine owner. That same year, Davis acquired a Connecticut farm, which was conveniently located near the Branchville station with trains going to New York City's Grand Central Terminal. Two years later, Weir bought a painting for himself for $560. Davis saw the painting, wanted it, and offered to give Weir the 153-acre farm in exchange for the painting plus $10. This once-in-a-lifetime real estate flip gave rise to the cradle of American Impressionism.

The farm became a summer/autumn retreat from the New York City life of Weir and Anna Dwight Baker, who married in 1883, as did the home in Windham, Connecticut, owned by Weir's in-laws. During this era in the country's history, Americans were looking to reconnect with nature. The dual national traumas of 1865—the Civil War and the assassination of Pres. Abraham Lincoln—were still fresh in the nation's psyche. Moreover, industrialization and immigration ushered in rapid social, cultural, and political changes. The farm's proximity to the Branchville railroad station gave the young couple commutable access to the countryside without sacrificing Weir's need to be close to New York City to maintain his professional connections, especially with galleries for the sale of his work.

They had three daughters—Caroline ("Caro"), Dorothy, and Cora—all of whom possessed artistic talents. Caro was a book-binder and painter, Dorothy was a painter as well as a writer, and Cora was an avid garden designer. Their mother, Anna, died in 1882 from childbirth-related complications. Anna's sister Ella cared for the children while Weir mourned. In 1883, Weir married Ella. In 1885, Weir had a studio constructed at the farm. By the 1890s, his landscapes reflected the Impressionist style; as a prominent leader in the movement, he co-founded the Ten American Painters in 1898 to advance Impressionism in the United States. By 1915, Weir was on the board of directors of the Metropolitan Museum of Art.

His growing influence and wealth prompted Weir to have the farmhouse expanded by architects Charles A. Platt in 1900 and McKim, Mead & White in 1911 to accommodate the guests who visited him such as Childe Hassam, Frederic Remington, Albert Pinkham Ryder, John Singer Sargent, John Henry Twachtman, Stanford White, and Weir's half-brother John Ferguson Weir, the first dean of fine arts at Yale University. Weir also expanded his acreage and purchased the Webb Farm across the road.

When Weir died in 1919 at age 67, his wife and three daughters inherited his estate. In 1922, Caro and Cora transferred their rights to the farm to Ella and Dorothy; Dorothy (1890–1947) lived at the farm during the summers to care for her stepmother, Ella. When Ella died in 1930 Dorothy inherited the property, and Cora (1892–1986) gave birth to Charles Burlingham Jr. The following year Cora took possession of the Webb farm portion, and Dorothy married Mahonri Mackintosh Young (1877–1957), a renowned sculptor and a grandson of Brigham Young. A studio for Young was constructed next to Weir's in 1932 where the Salt Lake City monument *This is the Place* was created. As Burlingham later recounted, Dorothy continued Weir's legacy as "she was an extraordinary person by any standard and a substantial talent in her own right. She had studied art at her father's elbow and later attended the National Academy of Design. She painted in oils and watercolors and was a superb print maker."

When Dorothy passed away of cancer in 1947, her husband, Mahonri, inherited the farm. Upon his death in 1958, his heirs subdivided the property and sold two parcels to Sperry Andrews (1917–2005) and his wife, Doris Bass Andrews (1908–2003). The Andrews were artists and had befriended Mahonri in 1952. Doris preserved the farm, and along with Sperry, joined Cora in opposing the construction of housing on former Weir farmland owned by others. In 1990, the saved 60 acres became Weir Farm National Historic Site, and the Andrews were granted life tenancy on the property. After they passed away, the house and studios became available for a comprehensive study, renovation, and restoration process. When the historic structures were finally opened to the public in 2014, the park became whole; visitors who could previously only access the grounds could now enter the house and studios. The big story of this small park contributes to the American experience of transformation and will be commemorated by the striking of a special Weir Farm quarter in 2020 as part of the US Mint's America the Beautiful series.

The contemporary photographs in this book are the first to artistically document that transformation. The collection was initiated after Charles Burlingham Jr. saw some of the early landscape photographs in 2011. The park then commissioned a series of photographic collections, especially of the buildings' interiors before and after restoration. The rooms were closed to the public and largely empty of furnishings for the first time in 130 years. These rare views and perspectives cannot be seen on a guided tour and focus on details and features that might go unnoticed in their fully furnished settings after the renovation. The unique photographs caught the attention of Sen. Joseph I. Lieberman and Brigham Young University, with each presenting high-profile exhibitions that garnered significant media coverage and interest from art experts.

Author Hildegard Cummings described the "haunting images of doors and windows in J. Alden Weir's summer place" as "openings into the soul of the painter." Dr. Anne E. Dawson, the art history chair at Eastern Connecticut State University, observed that "Having read so many of Weir's letters, the images take me even closer to understanding his artistic and personal life. These photographs offer essential research material for anyone interested in the life and art of this preeminent American Impressionist painter." For Peter Trippi, the editor of *Fine Art*

Connoisseur magazine, "the photographs of architecture and interiors are not only beautiful, but also somehow reveal something deeper and more significant about the structure's atmosphere, sometimes even its spirit."

If a picture is worth a thousand words, then perhaps these approbations from those who have keenly studied Weir suggest that the story of this painter, his art, his farm, and the generations of artists who followed will be communicated to new audiences in a way that far exceeds the words in this book. Thousands of pages of research materials were read, and thousands of photographs were studied—all of which went through a painstaking process of distillation. There is much more to learn about Weir and his farm than can possibly be covered here. Rather, this book is an introduction and a springboard to mining the historical and artistic depths of the subject.

A select number of representative works by Weir are included in the book. When references are made to other specific works of art, readers are encouraged to search online to see them unencumbered by space constraints and licensing restrictions. Opportunities to see Weir's artwork in person should be sought out. Major museums such as the Metropolitan Museum of Art in New York and the National Gallery of Art, the Phillips Collection, and the Smithsonian American Art Museum—all in Washington, DC—have Weirs in their collections. The Brigham Young University Museum of Art in Utah has the largest collection. In Connecticut, Weirs can be seen at Davison Art Center, Florence Griswold Museum, Lyman Allyn Art Museum, Mattatuck Museum, New Britain Museum of American Art, Wadsworth Atheneum Museum of Art, and Yale University Art Gallery. The photographs in this book are periodically on exhibition by the National Park Service, legislative offices, museums, galleries, and other public spaces.

The best experience is to visit Weir Farm National Historic Site to see the home and studio of America's most beloved Impressionist, Julian Alden Weir, and walk in the footsteps of generations of world-class artists.

One

CONNECTICUT'S FIRST NATIONAL PARK

Weir Farm National Historic Site offers much to see and do. The 68-acre site, established in 1990, is the only national park in the country dedicated to American Impressionist painting. It is home to one of the finest remaining landscapes that inspired the creation of iconic paintings, which can be seen at the Metropolitan Museum of Art and other world-class institutions. Unlike a conventional museum, it is a unique experience to be able to enter the home and studio of a leading painter, see his artwork and his brushes, paints, and palettes, and then see the very locations that inspired his work.

For those with an appreciation of architecture, the buildings spanning the Revolutionary War to World War II will be of interest, especially the very rare U-shaped barn. A tour inside the farmhouse gives a sense of what it was like to live as Weir and his family did. The furnishings, wallpaper, carpets, stained glass, and whimsical treatments form a wildly eccentric composition that might just trigger some creative ideas for home decorating.

The park, however, features much more than the passive intake of information from ranger-led tours and self-guiding brochures. Weir Farm is a creative playground for amateur and professional artists of all ages. On any given day, painters nestle into scenic spots with their easels, and photographers roam with cameras. Children express their interpretation of the grounds with art supplies borrowed from the park. Free workshops in painting and photography are also offered for both beginners and the experienced.

Creativity at Weir Farm is not limited to traditional two-dimensional visual arts. The grounds provide a variety of artistically distinctive landscape features. There are historic gardens and orchards as well as ornamental fixtures such as stone terraces, rustic gates, a fountain, and sundial. Hikers, bird watchers, and dog walkers will enjoy the gentle trails into the natural beauty of the meadows, woods, marshes, and Weir Pond.

It is the totality of these experiences that truly makes Weir Farm one of America's national parks for the arts.

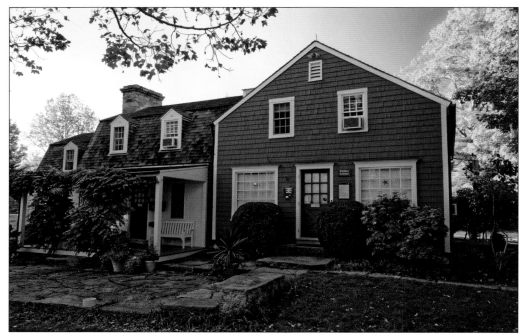

The first stop is the visitor center located within the Burlingham House, the original core of which dates to around 1775. Exhibitions at the center's gallery space have included original artwork by the Weirs, Youngs, and Andrews families—all of whom have lived on the property—as well as fine art photography and paintings by contemporary artists. The Burlingham House was part of the Webb Farm that Weir purchased to expand his property. Twelve years after his death in 1919, his daughter Cora and her husband, Charles Burlingham Sr., took possession of this parcel, and she constructed the terraced gardens pictured below.

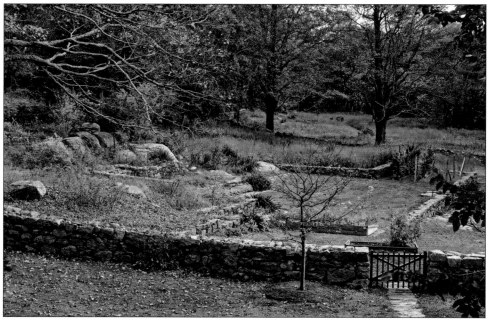

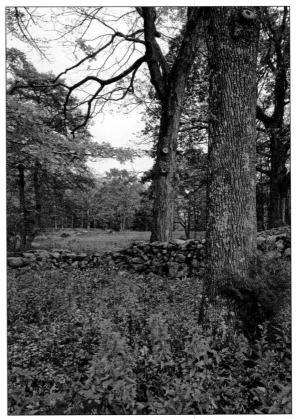

The landscape seen in the photograph to the right is remarkably unchanged from Weir's time. A survey conducted by Ridgefield Preservation Trust under a grant by the Connecticut Historical Commission found that the farm was "the only completely intact site of an American Impressionist painter." So, a visit to the park is the closest to experiencing what it was like to live and work as an important artist at that time in America's history. Another defining feature near the visitor center is Cora Weir Burlingham's Sunken Garden, which was photographed in 1956 by the Gottscho-Schleisner team for the book *Treasury of American Gardens*.

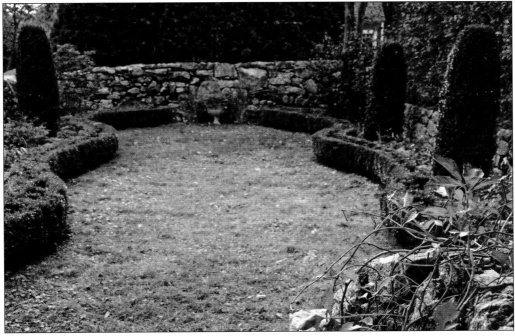

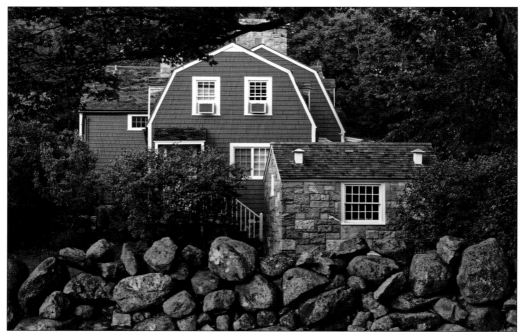

The contemporary and 1980 photographs show the Potting Shed that was added by the Burlinghams near the Sunken Garden during the late 1930s to early 1940s. The one-room structure was used for potting plants and storing garden tools and supplies. Inside are unpainted wall cupboards, storage spaces, and a floor cabinet all made of pine along with a work counter and a sink. The flooring is two-inch-thick unglazed clay tiles. The shed is constructed of ashlar blocks of granite that were locally quarried. This is unusual because ashlar is a finely cut stone often seen in important buildings like town halls and churches. (Below, WFNHS.)

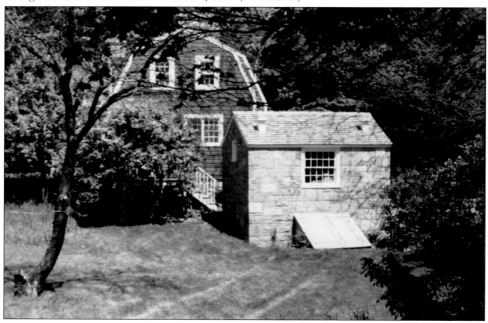

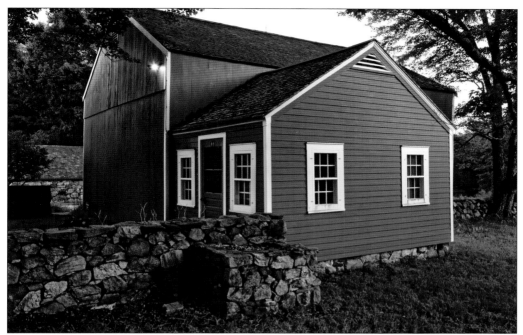

Seen from the rear is the Burlingham Barn (constructed between 1775 and 1843) located about 100 yards from the visitor center. The two-story barn is 900 square feet, has a rectangular gable roof, and is set on a dry fieldstone foundation. It is a typical example of an English barn, with its major doorway located in the middle of the side wall (out of view here). Today, the barn is a meeting space. Pictured below is one of the wells in the park. The Burlingham Barn lies just behind the red woodshed (built around 1850), forming a courtyard flanked by stone walls.

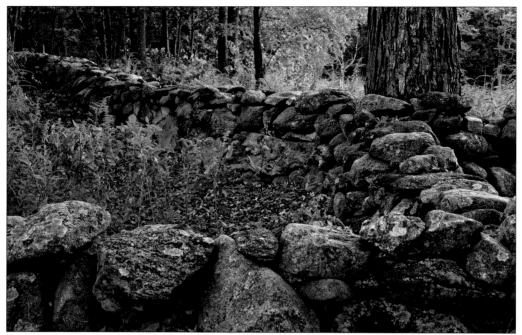

Weir Preserve was created in 1969 when Cora Weir Burlingham donated 37 acres of the Webb Farm to the Nature Conservancy. The preserve—contiguous with, but not a part of, the park—eventually expanded to a total of 110 acres. The stone walls were a typical method for small New England farms to divide up what was formerly pasture land. The preserve's three-mile trail system wends its way through interesting landscape features like the eastern skunk cabbage, which emits a foul odor when any of its leaves are bruised or broken. Hikers will also encounter fields, streams, wetlands, and rock ledges.

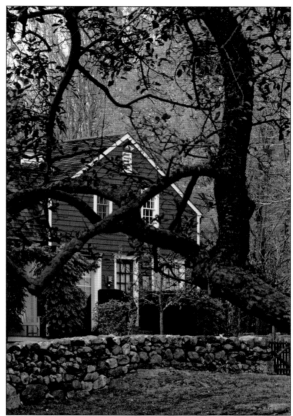

Returning to the visitor center, a path in the rear leads to the Weir House. In autumn, the walk is enhanced by a spectacular display of bright orange leaves from sugar maple trees. Through archival photographs, the park identified specific sugar maples that were present around 1940. The path crosses a field where Cora Weir Burlingham planted her Victory Garden, part of the Webb Farm, which Weir would have seen from his porch. During World War II, the US government encouraged citizens to ration and help feed the troops by growing vegetables and fruits.

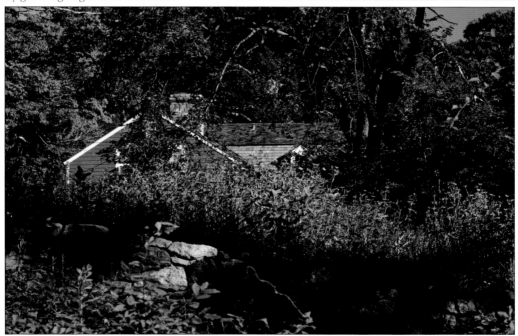

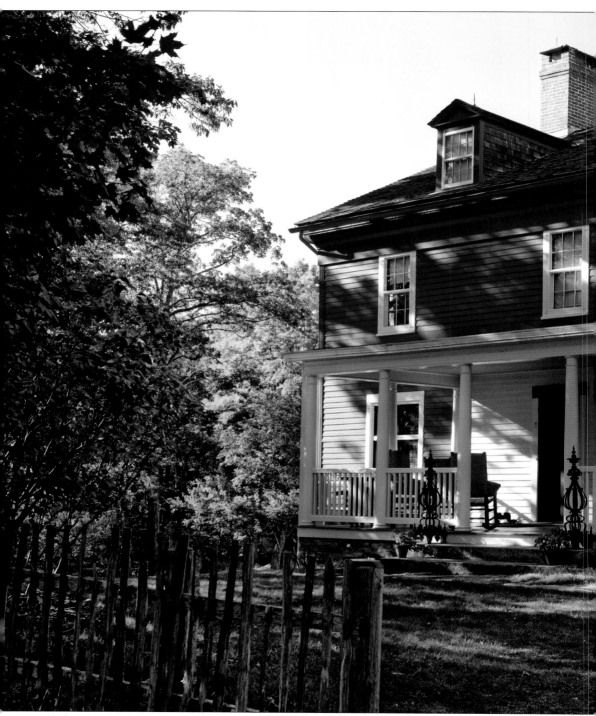

At last, visitors see one of the centerpieces of the park: the Weir House. In 1882, Weir and Anna Dwight Baker were engaged three weeks after having met in his drawing class. Later that year, New York art collector Erwin Davis and Weir made a deal. In exchange for a painting Weir had

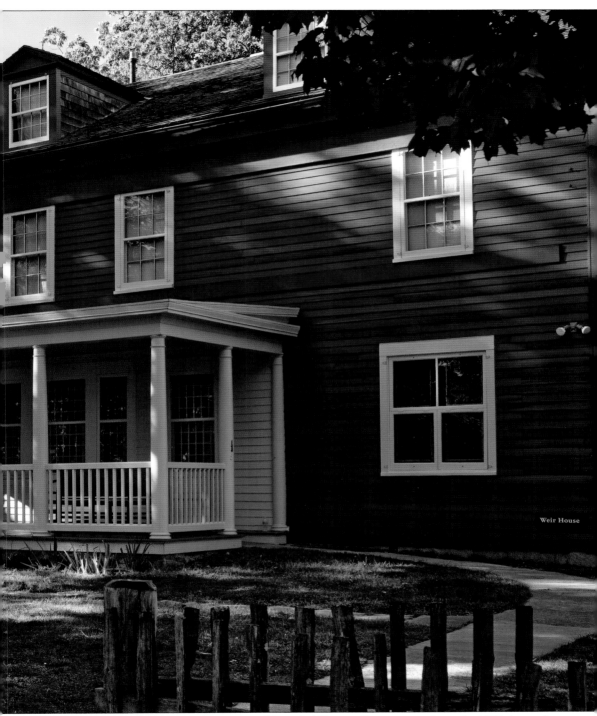

Weir House

acquired plus $10, he became the owner of Davis's 153-acre Connecticut farm. In 1883, he and Anna wed, and the farm would figure prominently in their lives. The farmhouse, with an original core built around 1780, was expanded by Weir three times to accommodate friends and guests.

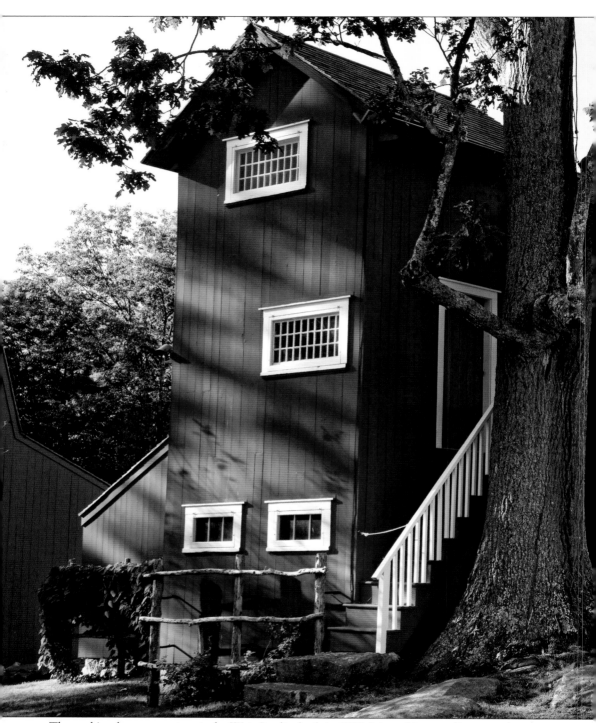

The park's other centerpiece is the Weir Studio, built in 1885. It is architecturally unique because it was custom designed for Weir, presumably by Charles A. Platt, who expanded the house. The section to the left of the tree is a water tower added about 1888 to 1901. The tank was filled with water from

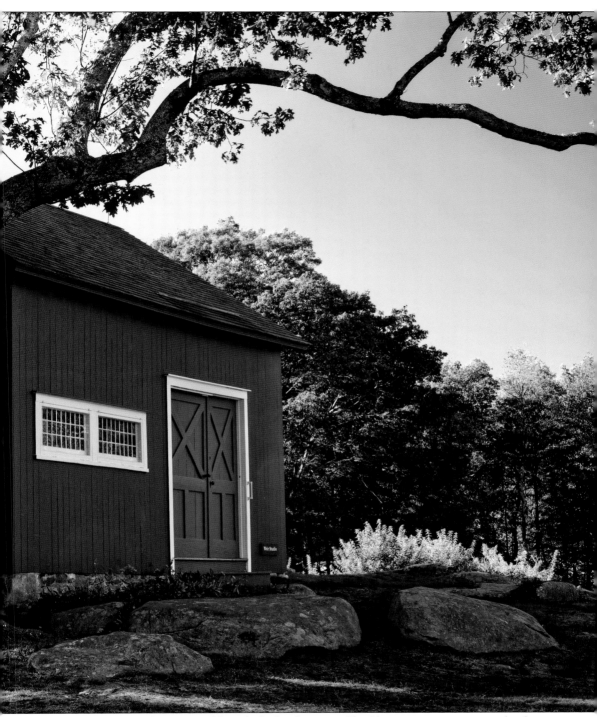

a pump house across the street. Although the landscape and building exteriors are restored to how they appeared around 1940, the studio's interior is restored to the 1915 era to reflect Weir's use of the space in creating works that placed him at the forefront of American Impressionism.

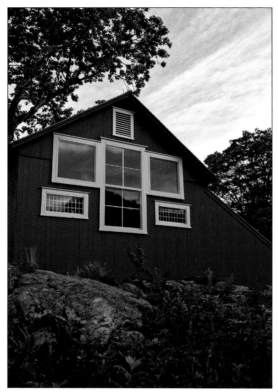

The north end of the studio has the distinctive multi-paned windows along with much larger windows to let in the northern light favored by artists for centuries. The cool light from this direction is soft, diffused, and consistent throughout the day. It is much more flattering than direct sunlight, which is harsh and casts shifting shadows as the sun moves during the day. The studio was built on what is believed to be the highest rock outcropping on the property. It is also just steps away from the peaceful and rustically decorative Secret Garden (below).

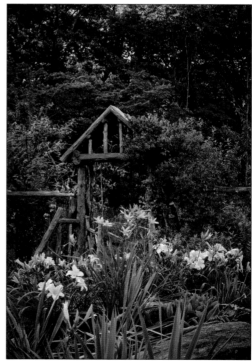

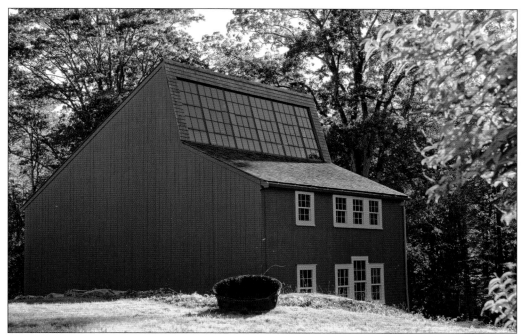

In 1932, shortly after marrying Weir's daughter Dorothy, Mahonri Young had his own architecturally unique studio built. It was designed to accommodate Young's large-scale sculptures. The large cast-iron kettle in the foreground above was a scalding vat to prepare slaughtered hogs for butchering. The English barn pictured below dates to around 1829 and is a rare sight. In 18th-century England, it was common for barns to have a main structure with connected buildings so that the three sides formed a U-shape, resulting in an inner courtyard. This barn type was brought over to the colonial Northeast by settlers, but few remain today.

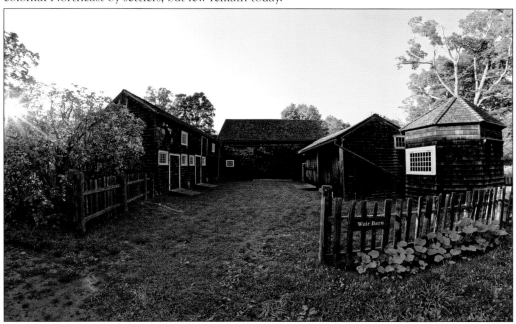

In addition to the barn, other farm outbuildings include the corn crib pictured above. The air circulated through the wooden slats in the walls and kept the cobs dry. The Beers cemetery plot is not part of the park but is a short walk from the corn crib. In 1789 and 1797, Anthony Beers bought parcels from the original 1745 land grant. In 1836, his son Lewis Beers purchased additional property, and his heirs sold the farm to the Gilbert & Bennett Manufacturing Company. Later, Erwin Davis bought the property and, in turn, made the now famous deal with Weir.

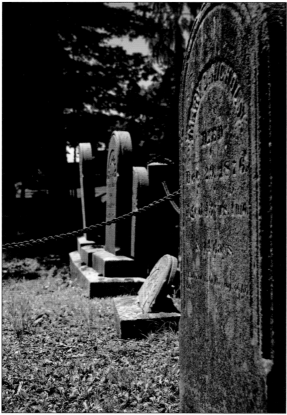

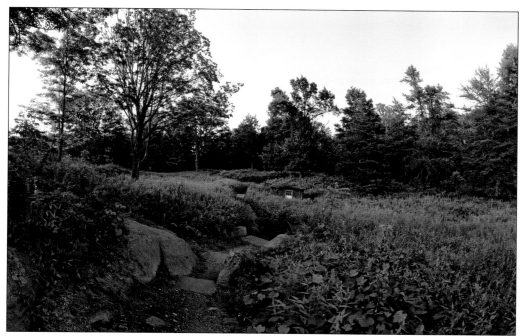

The final and largest section of Weir Farm—38 acres—lies across Nod Hill Road opposite the Weir House. A trail leads across Truants' Meadow, named after Weir's famous painting. Within the meadow is a reproduction of Weir's 1880 "Palace Car"—a small portable studio on runners that his oxen dragged to different locations so that he could paint outdoors year-round. The trail continues over a wetland area and into the woods. Seven major wetland areas have been identified that, together, comprise about one-third of the park's total acreage. Wetlands trap and slowly release water, thereby slowing floodwaters and reducing erosion.

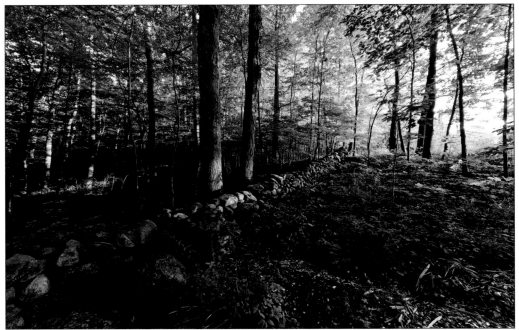

In the woods, there is a sense of mystery in the seemingly purposeless stone walls that track the slopes. The walls are the last vestiges of a world that has disappeared. What is now a forest was once an area cleared of trees for farming and grazing. The stones marked property lines and kept animals from escaping. The woods then open up to Weir Pond. After finishing *The Truants*, Weir exhibited the painting at the Boston Art Club in 1896. He won the $2,500 first prize, purchased 10 acres, constructed a nearly four-acre pond, and stocked it with largemouth bass for fishing.

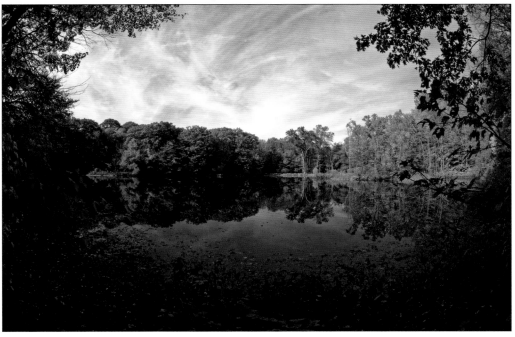

Two

THE GREAT GOOD PLACE

Weir Farm is comprised of three main areas: the Burlingham, Weir, and Woodland/Pond complexes. Together they form the 68-acre core from Weir's original 238 acres. After Weir's death in 1919, and especially after World War II, farming declined and the land transitioned to suburban housing. By 1963, the landscape that inspired generations came under the threat of bulldozers. Preservation efforts reached a turning point in 1969 when Cora Weir Burlingham donated 37 acres (today's Weir Preserve) to the Nature Conservancy. Together with Doris and Sperry Andrews—who owned and lived in the Weir complex—their activism resulted in petitions, rallies, and the forming of Citizens to Preserve Weir Farm in 1970 and the Committee to Save Weir Pond in 1976.

In 1978, research by the Ridgefield Preservation Trust (RPT) concluded that the farm was the only completely intact site of an American Impressionist painter. The RPT received letters from major art institutions supporting the farm's inclusion in the National Register of Historic Places. John Wilmerding of the National Gallery of Art noted that the homes and studios of the majority of important 19th-century artists no longer exist. In 1983, a Weir retrospective exhibit was held at the Metropolitan Museum of Art. Then, in 1986, the Trust for Public Land (TPL) and the State of Connecticut began purchasing key acreage.

After a favorable study by the National Park Service (NPS), the Connecticut delegation of Sen. Joseph Lieberman, Sen. Christopher Dodd, and Congressman James Maloney introduced legislation, signed by Pres. George H.W. Bush on October 31, 1990, to establish Weir Farm National Historic Site. The Weir Farm Heritage Trust (WFHT) managed the site until the NPS staff's arrival in 1992. Additional land was eventually acquired through the state, the TPL, the WFHT, and the Andrews, who reserved the right to live out their lives on the property.

Weir referred to the farm as "the Great Good Place," recalling the Henry James story of a writer seeking a place of respite from his busy life. As a national park, the farm was once again a place of rest.

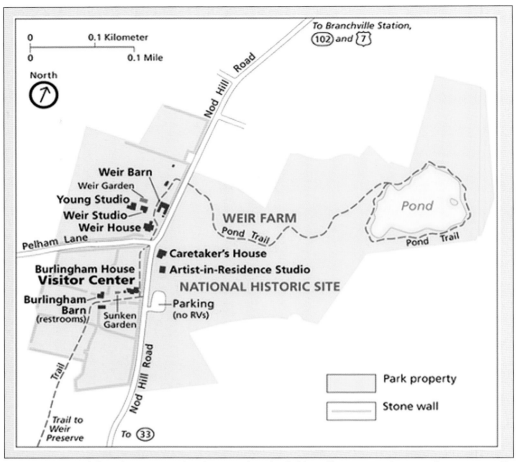

Weir Farm straddles the towns of Wilton and Ridgefield. Pelham Lane (see map) cuts partially across from the west to the east—Ridgefield is above it, and Wilton is below. Nod Hill Road bisects the park in a north/south direction. The Burlingham complex is at lower left, and the Weir complex is directly above it. The Woodland/Pond complex is to the right of Nod Hill Road and includes the Caretaker's House and studio for the artist-in-residence program operated by Weir Farm Art Center. The illustration below presents a bird's-eye view as if traveling diagonally across Pelham Lane, at lower left. (Both, WFNHS.)

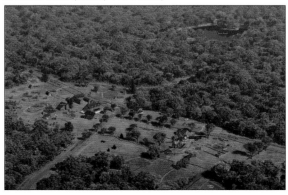

Cora Weir Burlingham, seen at right in 1973, triggered the land acquisition process with her donation of 37 acres. In 1986, the State of Connecticut, with the assistance of state senator John Matthews, appropriated $2.7 million to acquire and protect land at the site that was saved by the Trust for Public Land. Leaders of the TPL are pictured below in front of the Burlingham House during a tour of Weir Farm in the mid-1980s. From left to right are Martin Rosen, Clifford Emanuelson, Ernest Cook, Robert McIntyre, Senator Matthews, Cathy Barner, and Charles Lay, a grandson of Mahonri Young. (Both, WFNHS.)

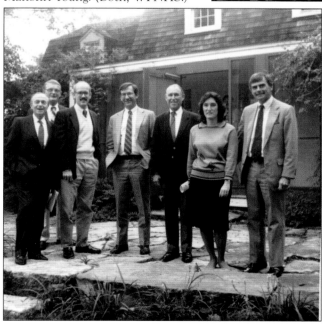

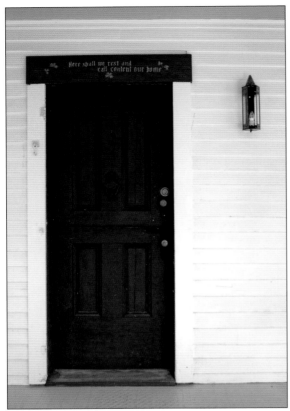

Thanks to persistent efforts spanning decades, Weir Farm was not lost to history or destroyed by commercial interests like other artist homes and studios. The purpose of the legislation establishing the park is to maintain the integrity of a setting that inspired artistic expression, encourage public enjoyment of this setting, and offer opportunities for the inspirational benefit and education of the American people. Indeed, the front door of Weir's house bears the hand-painted inscription, "Here shall we rest and call content our home." The Secret Garden, a short walk away, also provides a retreat for enjoyment, inspiration, and rest.

The Secret Garden started out modestly in 1905 but by 1915 was a semi-formal garden like many Impressionist painters had. The garden is enclosed by hedgerows and features a fountain, a sundial, and two rustic gates. There are sketches by Weir that are believed to depict the area. The Secret Garden is a good example of how the artistic process can go beyond the borders of a canvas to create a specific environment where one can enjoy beauty and rest. In the mid-1990s, the Ridgefield Garden Club worked with the National Park Service and the Olmsted Center for Landscape Preservation to restore the garden.

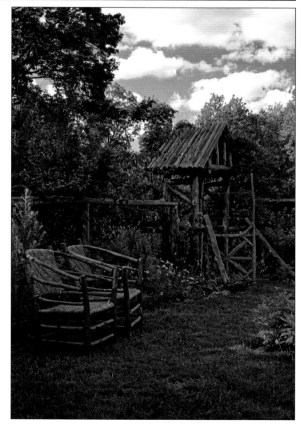

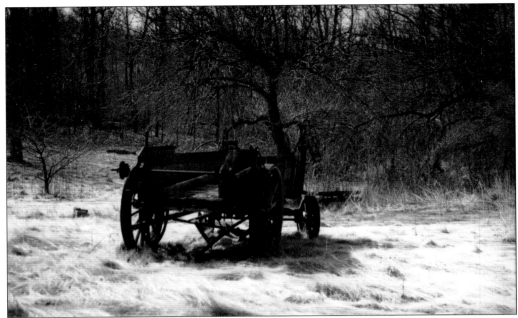

Those whose eyes patiently explore the grounds will be rewarded with other artistic views waiting to be found. During the Weir and Young tenures, wagons were used for trips between the house and the woods, pond, and fields. Tucked away in the northernmost end of the Weir complex are the remnants of the wagons, farm machinery, and smaller equipment once housed by a shed that collapsed in 1980. Wagons and their remnants are romantically picturesque and can suggest a sense of nostalgia. Today, even the weathered spokes and rusted hubs of the remaining wagon wheels have a haunting allure. (Above, WFNHS.)

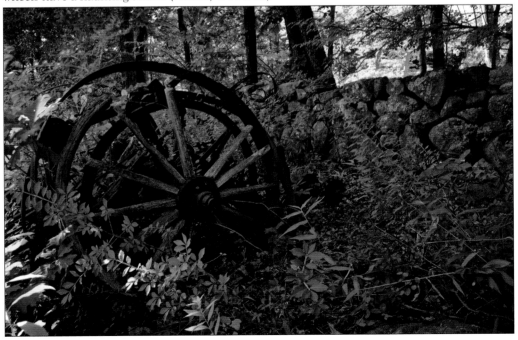

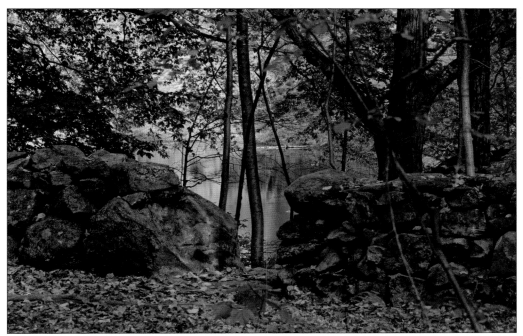

Other unique landscape features are the stone walls and the pond. Although man-made, they are maintained as cultural treasures, especially Weir's favorite fishing spot, constructed from his exhibition prize money. The shape of the pond when viewed from above suggests the outline of a fish, with the small island at its eastern end representing the eye. Whether by design or happenstance, it is a fitting motif for Weir. The stone walls vary. Some have an ornamental structure and finish like the one pictured below, while others are loose piles. A third type of wall combines elements of the other two.

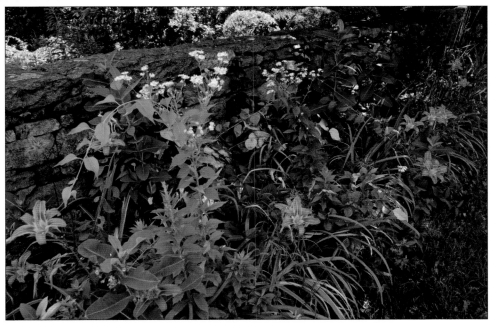

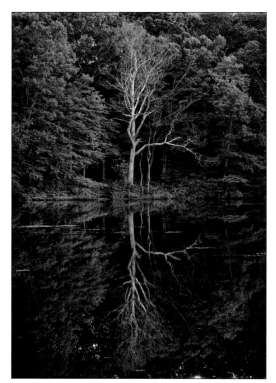

To enter Weir Farm is to step into a painting and see differently. A chief observation of the Impressionists was natural light's behavior on objects. How light reflected against surfaces, especially on water, provided rich creative possibilities. Light's ephemeral movement was captured with immediate brushstrokes of bright, solid paint. These fleeting moments can still be experienced today during all seasons in places such as the pond, where light can be reflected as a mirror image or as shimmering but painterly distortions. The evanescence can be captured with paints like the Impressionists did or with cameras and other contemporary methods of expression.

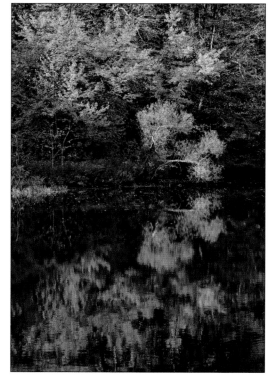

Critical looking can be subtle and unconventional, just like Impressionism was in its day. Dorothy Weir Young recalled that her father did not like having everything taken in at a glance. He preferred things being gradually disclosed when the viewer least expected it. These images are contemporary examples. The tight composition on the mesh of roots at right implies an overturned tree. The image below is a photograph of the pond. Keen observation of water conditions and an unorthodox composition resulted in an abstract image without digital manipulation. In 2010, lower water depths and excessive nutrients produced these blooms of algae.

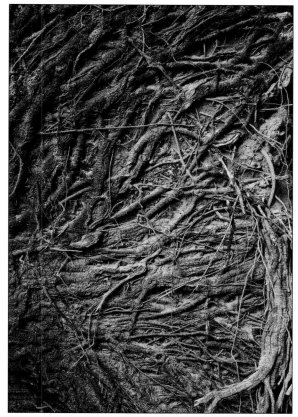

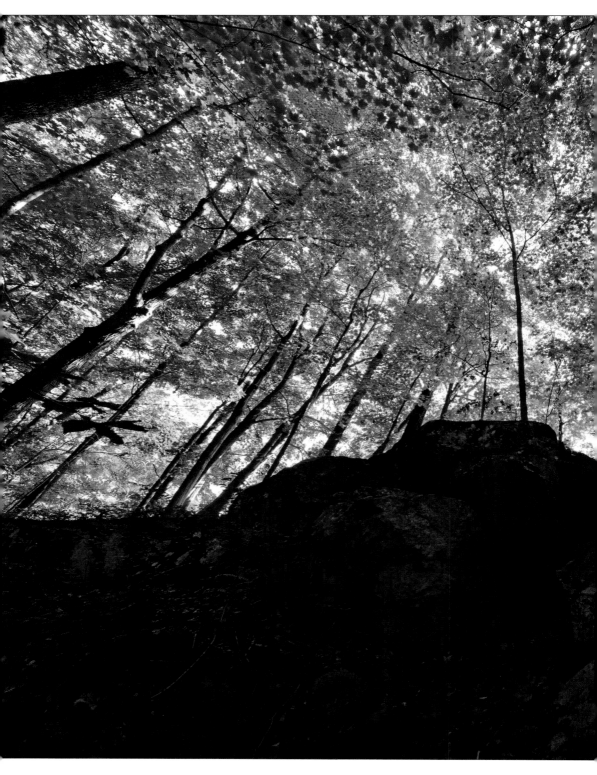

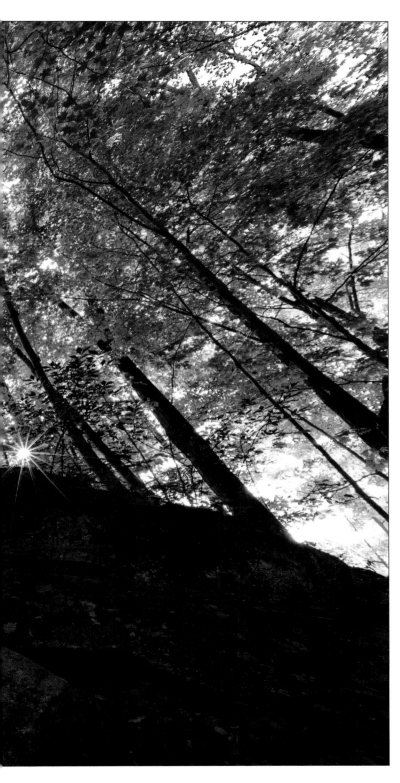

Weir's original intent for buying the farm was to use it as a hunting lodge. Later, he would come to see the land within his boundary markers as a canvas tacked across a wooden stretcher. He began developing the site as both a working gentleman's farm and as a catalyst for the development of his art. Land was cleared, boulders were moved, and trees were relocated. Other enhancements to the property include the Secret Garden and the pond for leisure and painting. However, some features, such as the rock ledges in the Woodland/Pond complex, did not need Weir's artistic intervention.

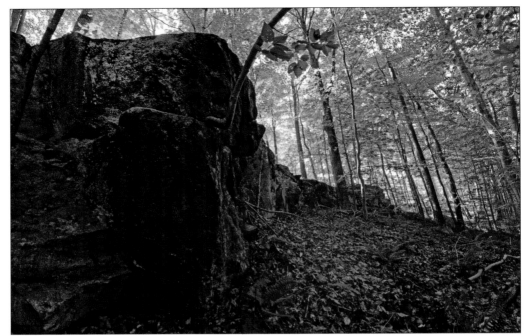

The landscape that inspired Weir, the Youngs, and the Andrews, as well as current artists and visitors, owes its character to its geologic history. During the Ice Age, enormous frozen sheets advanced and retreated over what is now Connecticut. The repeated action of these sheets transported boulders (glacial erratics), exposed the bedrock (outcrops), and created an undulating topography with ledges, ridges, and gentle to fairly steep slopes. Such rock formations (above) can be seen near the artist-in-residence studio and are featured in Weir's c. 1905 *Upland Pasture* and c. 1910–1919 *Woodland Rocks* (below). (Below, the Phillips Collection.)

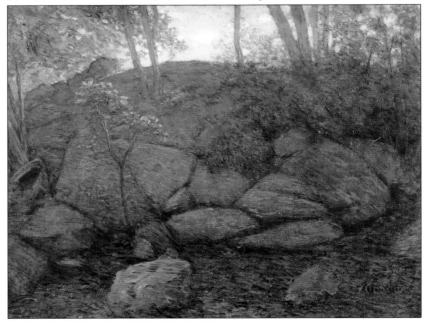

For almost 40 years, the landscape piqued Weir's imagination and for another century continued as a creative center for generations of owners and artists. The tradition endures at Weir Farm. Anyone can paint pictures in their mind. A walk around the pond might trace the outline of a fish. Gazing at the water surface may conjure up abstractions. Musing over the remnants of wheels or stone walls can transport one back to when rattling wagons were heard and seen crossing the open farm fields. What about the tree stumps? What is hidden within their recesses? (Below, Rita Dieguez.)

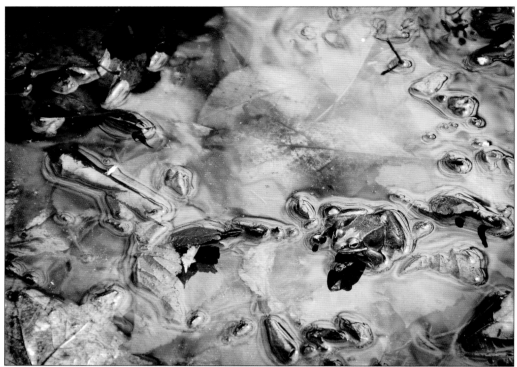

In addition to imagined creatures, there is an ecosystem of amphibians. Spring peepers are heard, if not seen, in the wetlands. Their chick-like breeding call produces a hypnotic chorus signaling the coming of spring. For Albert Pinkham Ryder, an eccentric New York City artist who frequently visited Weir, this country sound was unfamiliar and terrifying. Birdwatchers will be treated to at least 74 species. Wild turkeys are common but once were a rare sight. By the early 1800s, they were eliminated due to forest clearing and severe winters. They were successfully restored to all 169 Connecticut towns between 1975 and 1992, when a total of 356 wild turkeys were released at 18 sites.

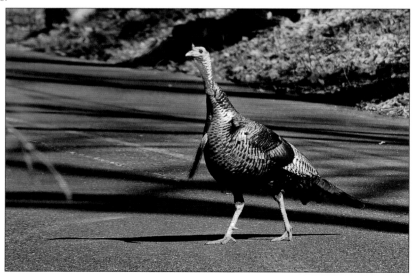

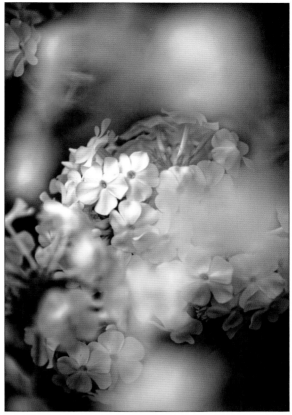

Over 470 species of plants, such as white flox, have been identified in the fields and gardens. In the 1880s, Weir's still lifes of flowers helped establish him in the New York art world. Although the painting that Weir traded for the farm is unknown, one account—told to his daughter Dorothy Weir Young by her father's close friend—suggests it was of a flower. Weir grew a variety of vegetables on his farm as well as apples in the orchard. Young was privy to yet another account on the nature of the famous painting that Weir traded. Her uncle Charles recalls the painting was of "some fruit."

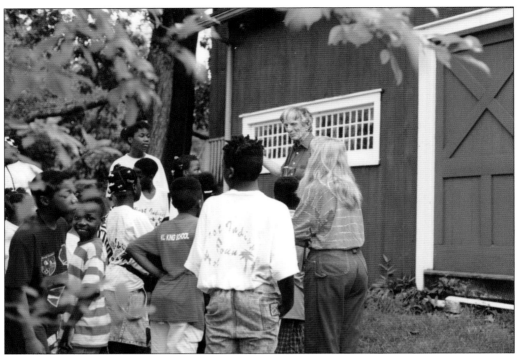

The landscape continues to inspire new artists. Here, in front of the Weir Studio, a school group in June 1992 meets, and learns from, living history—Sperry Andrews, the last artist-owner. The park makes it a priority to maintain a vital artistic tradition in keeping with the mission expressed by Congress. The Take Part in Art program encourages visitors to try their hand at creativity with their own art supplies or by freely borrowing materials from the park, like the inner-city Girl Scouts pictured below. Free workshops taught by professional artists are also available for all experience levels. (Both, WFNHS.)

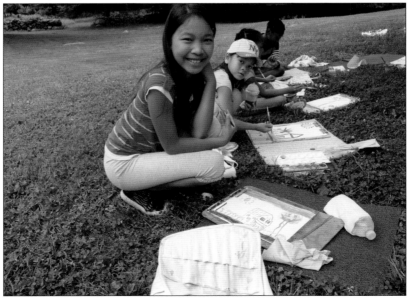

In 1877, Weir and other New York painters sought kinship and freedom through their Tile Club, which included architects, sculptors, writers, and musicians, who all painted on tiles. The club became famous for its antics and expeditions to Long Island wearing eccentric outfits. The contemporary version at right fuses a photograph of a Delft tile from Weir's house onto an actual tile. Later, Weir's farm became a liberating refuge from day-to-day concerns and conventions that impede creativity and stifle idiosyncrasies. Today, artists such as Connecticut musician Saint, pictured below, can seek out that same sense of freedom at Weir Farm.

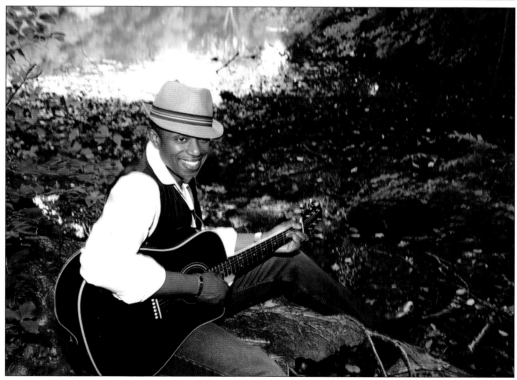

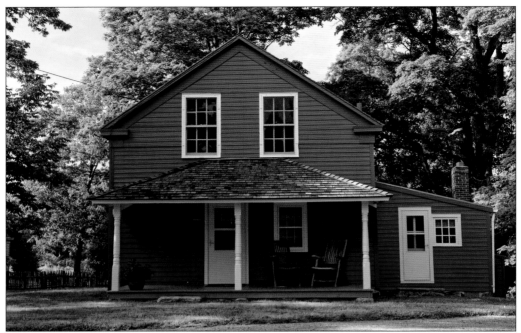

While visitors are welcome to bring their musical instruments, easels, and cameras, the park also has a formal artist-in-residence program. Through an annual call, visual artists apply to compete for 10 coveted month-long residencies. To date, the program's jury process has selected more than 220 artists from across the United States, as well as Australia, England, Germany, India, Ireland, South Africa, the Netherlands, and Tunisia. The artists live in the comfortably furnished 1,100-square-foot historic Caretaker's House, which is located across from the Weir House. The program is one of many operating in national parks around the country.

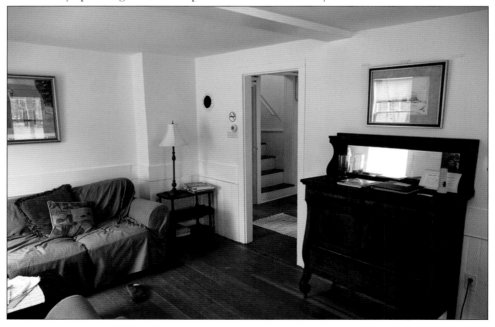

Artists-in-residence run the gamut from the traditional to the experimental. For her 2005 project, Dutch-British artist Lilian Cooper had trees along the pond wrapped with text written on the same plastic surveyor's tape used to tag those needing pruning or felling. Each read like snatches of conversation from passing joggers. The 20 seemingly cryptic statements were put into context once the entire pond walk was made. Unwitting visitors provided Cooper with her project's title. "Sexy Trees" was the line causing the most response, with a number of visitors calling to report strange vandalism when, actually, it was installation art. (Above, WFNHS; below, Lilian Cooper.)

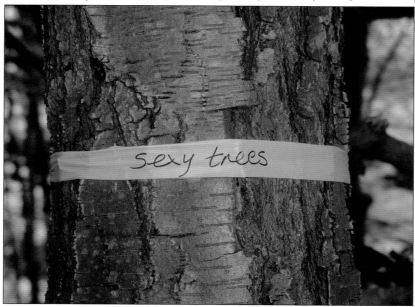

Artists are not limited to working outdoors. A few steps from the Caretaker's House is a large studio that the National Park Service constructed from a historic garage. While the character of the original structure was preserved, the space was transformed into a naturally lit state-of-the-art facility with back windows opening to a deck overlooking the woods. Robert Faesy of Faesy-Smith Architects broke ground in October 2008 and completed the studio in June 2010. The project was paid for mostly with funding from the National Park Service. A grant from the federal Save America's Treasures program also contributed.

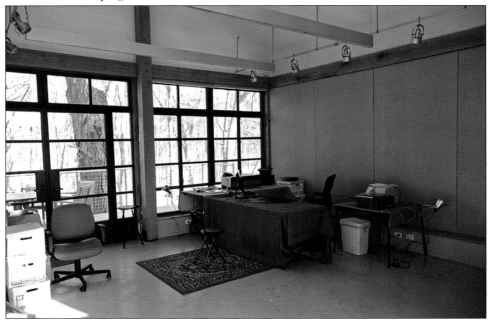

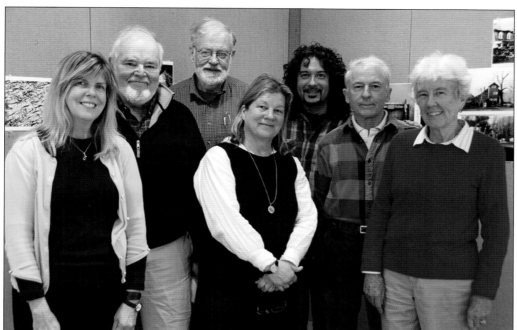

Since 1998, Weir Farm Art Center has managed the park's highly acclaimed artist-in-residence program. Pictured above during an open studio visit in 2011 are, from left to right, Janice Hess (executive director), Charles Burlingham Jr. (president), Robert Faesy (vice president), Korin Heiser, Xiomáro (March 2011 artist-in-residence), Bruce Beebe (vice president), and Nancy Faesy (vice president). Friends of Weir Farm support the park through fundraising efforts, attracting new and diverse visitors, and many other activities. The board of directors (right) are, from left to right, Judy Wander, Liz Castagna, Sheila Wakoff, and James Burch. (Right, Friends of Weir Farm.)

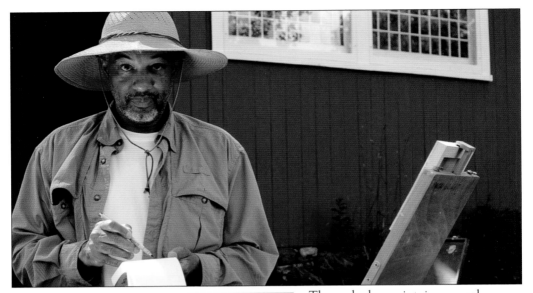

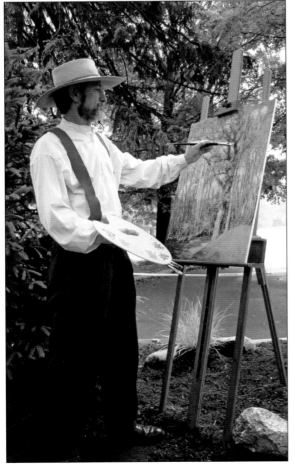

The park also maintains several relationships with professional artists such as Dmitri Wright, seen above in a still from the short film *Weir Farm Presents Dmitri Wright, an American Impressionist in the Tradition*. Wright is part of a cadre of artist-teachers helping to develop the next generation of talent. Another artist, Marc Chabot, left, was a visiting artist in 1995 and then taught visitors of all ages through the Take Part in Art program. His experience in the art world as a curator, appraiser, and private dealer in fine prints made him a wealth of knowledge for students. (Left, WFNHS.)

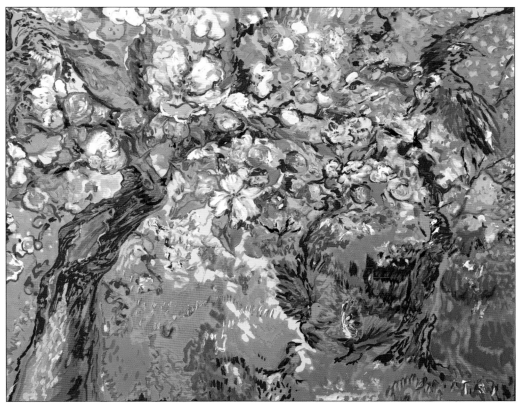

Dmitri Wright has been teaching outdoor painting workshops at Weir Farm since 2009. His oil-on-linen *Apple Blossoms–Weir Farm Opus 1* (2018), seen above, is a good example of how his work integrates representational, Impressionist, and Expressionist elements to create his own artistic vision. The brushwork juxtaposes color and captures the intensity and rhythmic movement of light. For Wright, it is about painting from one's sensations and not just from the eyes. Those artistic elements can also be expressed in photography, as in the image below focusing on a small portion of a decaying tree. (Above, Dmitri Wright.)

Pictured above in June 2018 are the attendees of the Art of Phoneography, Weir Farm's first photography workshop. The ubiquity of smartphones accounts for at least 75 percent of all photographs being created. The number of snapshots grows exponentially as digital technology and social media continue making the medium more accessible. Recognizing this cultural phenomenon, the free workshops instruct attendees on how to apply Weir's artistic principles to take creative smartphone photographs like the image below. The clean lines and modern composition are different from the snapshots often taken at Weir Farm. (Above, WFNHS; below, Martha Romaniello.)

Three

HOME IS
THE STARTING PLACE

May 24, 2014, was a historic day for Weir Farm. After a seven-year restoration process, the interiors of the Weir House, Weir Studio, and Young Studio were finally opened to the public. For the first time since the park's establishment in 1990, visitors could experience what it was like to live and work as an artist.

Although only the first floor of the house is historically furnished, it shows how Weir created an environment that inspires creativity. The rooms, furnished to their original colorful and wildly eccentric décor, are stunning. These spaces include the living room, library, guest bedroom, dining room, and pantries, and are as close to the original interiors as possible. About 85 percent of the furnishings were owned by the Weirs and Youngs and used in the house, with similar period pieces substituting for anything missing. Some of the art on display are also original works. The main working spaces of the studios are accessible for viewing as well.

It helped that Dorothy Weir Young maintained the house and property much as it was when her father, Julian, was alive. The subsequent owners, Sperry and Doris Andrews, also kept the interiors largely as they found them. As a result, the buildings and furnishings are restored to look as they appeared around 1940, as this is the period that best reflects the use of the site while still preserving the historic character during Weir's occupancy.

Accurately resurrecting such complex historical details was a four-phase process employing over 100 local contractors and National Park Service experts. For the initial phase—systems—new plumbing, electrical, fire detection, and fire suppression systems were installed. For the exteriors phase, new roofs were installed, and all the siding and windows were repaired and painted. Next came the interiors phase, when experts used forensic-like techniques to determine the original paint colors and wallpaper designs for reproduction. Last came the furnishings phase, as described above.

"Home is the starting place," Weir penned in a letter to his godson. For the park, the grand opening was like a new beginning.

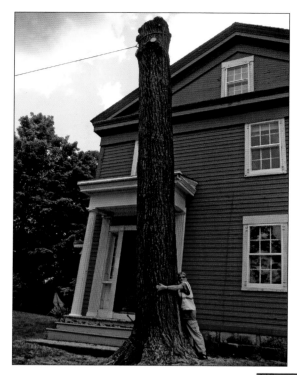

In June 2011, one original detail had to be removed: a Canadian hemlock that silently witnessed at least 175 years of history and had outlived all of the farm's residents. It was difficult for many—including Pat Clark, the park's administrative officer—to say goodbye, but only about 10 years remained in the tree's life due to insect damage. It was also interfering with the construction of an Americans with Disabilities Act (ADA)-compliant walkway and damaging the Weir House foundation and entrance steps. A new Canadian hemlock was planted farther away, and portions of the original tree were saved for interpretive, educational, and horticultural purposes. (Left, WFNHS.)

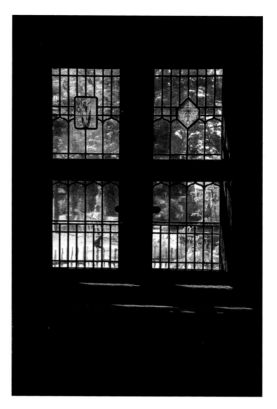

In July 2011, the Weir House library was emptied for restoration. At right, a worker carrying a ladder can be seen through the Dutch casement window, which features stained glass medallions on the top panes. The lily medallion was purchased new by Weir and his first wife, Anna, during their European honeymoon in 1883. It was installed in 1900 to complement the much older ones in the house. The glass is actually clear, not stained, with its surface colored by vitreous paint, silver stain, and translucent enamel. The lily appears to be a fanciful design inspired by the Madonna lily with tulip-like leaves.

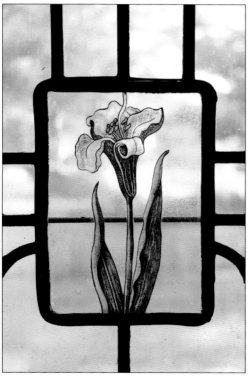

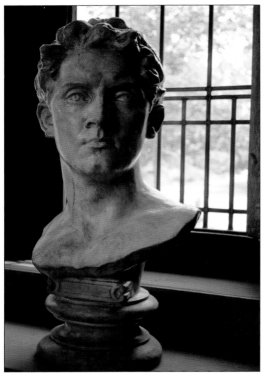

After the restoration, the library window features a plaster bust of a 28-year-old Weir. Pictured below is the 1880 sculpture, created by Weir's friend, Olin Levi Warner, as it appeared before cleaning, filling, and toning. The bronze versions, at the Metropolitan Museum of Art and at the Brooklyn Museum, were highly acclaimed. When Weir needed work samples for procuring portrait commissions, Warner returned the favor and posed for him. Tragically, Warner died in 1896 at age 52—at the height of his career—after being struck by a horse and carriage in New York City's Central Park. (Below, WFNHS.)

WEFA 2221
CCB 08—0039
5/27/2008

BEFORE TREATMENT

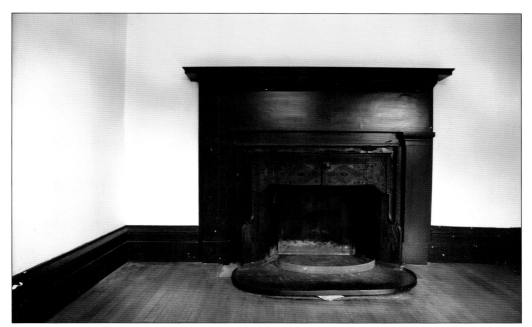

Across from the library is the living-room-turned-guest-bedroom known as the Ryder Room. Both rooms are on the first floor behind the hemlock tree. The bedroom was named for artist Albert Pinkham Ryder, a frequent visitor. Emptied of its contents for restoration, the Franklin stove was all that remained. After the restoration, the stove competes for attention especially with the St. Esprit wallpaper of blue poppies. In his portrait above the stove, Ryder's distant gaze is appropriately fixed off-frame. "Pinky," as Weir affectionately called him, was socially withdrawn and preferred this room because he could come and go without encountering other guests.

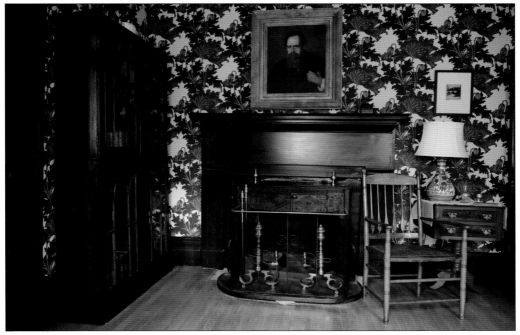

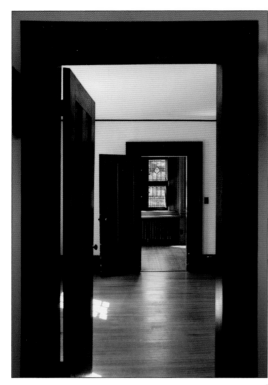

The photograph to the left is a pre-restoration view from the dressing room, through the Ryder Room, and into the library. The photograph below shows the same view after the restoration. The Iranian carpet is a custom reproduction of the early-20th-century original. The rug was made larger to protect the floor from foot traffic now that the house is open for public tours. To the right of the dressing room, and out of view, is a bathroom. These rooms were added as part of the 1911 alterations after the original living room was converted to sleeping quarters for guests like Ryder.

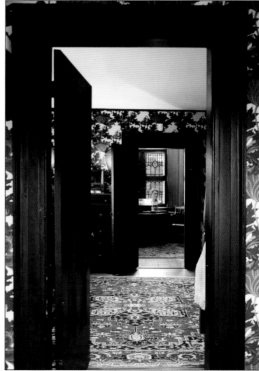

The library also opens into the living room, a long narrow space with two fireplaces due to Weir's expansion in 1900. The area in the foreground was originally the kitchen and became the sitting room. The fireplace smoked and was called "the artist." Its temperamental malfunctioning continued such that Sperry Andrews never lit it. Instead, at Christmas, he decorated the inside with balsam branches. The area in the background became the breakfast room with a new well-behaved fireplace dubbed "the gentleman." Fireplaces were the only source of warmth in the house until 1930, when Dorothy Weir Young had a heating system installed.

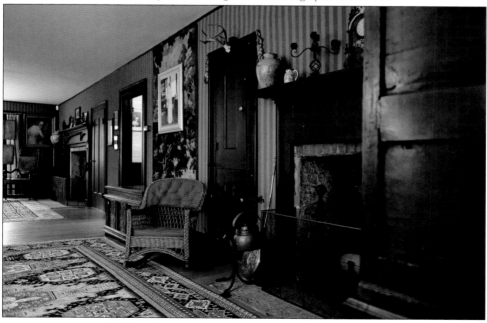

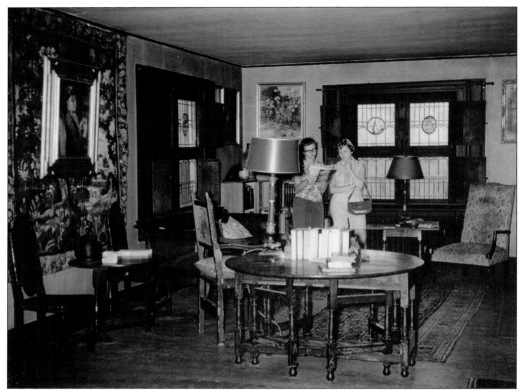

In 1936, Dorothy Weir Young removed the wallpaper and painted the living room coral red, as can be seen in the 1958 photograph above. For the restoration, the room was wallpapered just as it was during Weir's time. As in the library, the top panes of the Dutch casement windows display glass medallions purchased during the Weirs' honeymoon. The solid oak shutters are decorated with scrolled brass hardware. Below, the "W" from the initials EBW—for Weir's second wife, Ella Baker Weir—appears on the bottom of the left window with the other letters obscured by the shutter. (Above, WFNHS.)

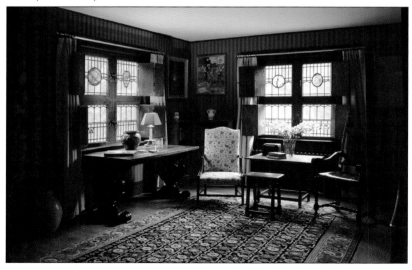

Around 1958, when the Andrews owned the house, the coral red living room was repainted in green. The park restored the gold leaf horns and scrolled Chinoiserie Revival–style wood brackets, with which Dorothy Weir Young embellished the closet door. Some coral red remains visible through the brackets as a testament to the continuous use of the house by several artist-owners. Fortunately, Weir's original 1901 green-striped wallpaper was found behind radiators, and a partial unused roll was discovered in the attic, thus enabling its reproduction. The wallpaper can be seen in Weir's c. 1905 painting *Caro Seated on a Chest*.

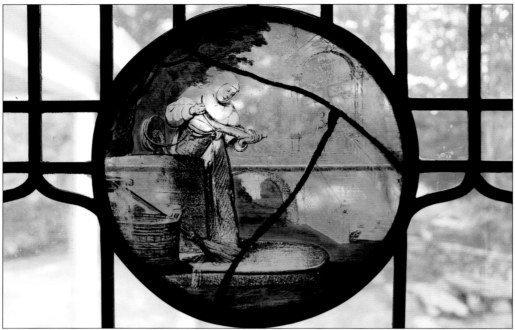

The artistry of the glass medallions enchanted the Weirs enough to have them shipped from Italy. The medallion above, from around 1500 to 1520, depicts a monk holding a fish at a well. The medallion below, also from the 16th century, is a detail from a larger piece illustrating the healing of Tobit's blindness and the expulsion of Sarah's demon. All of these scenes are rendered by hand on clear glass using vitreous paint, which is comprised of finely powdered glass and pigments. Firing in a kiln melts the paint, hardening it into a permanent layer of color over the glass surface.

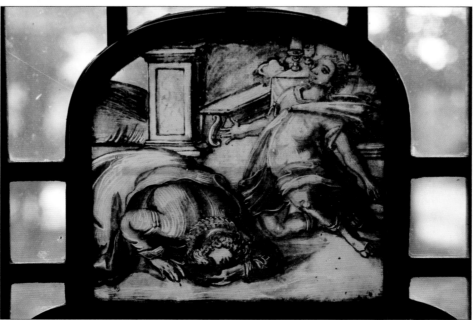

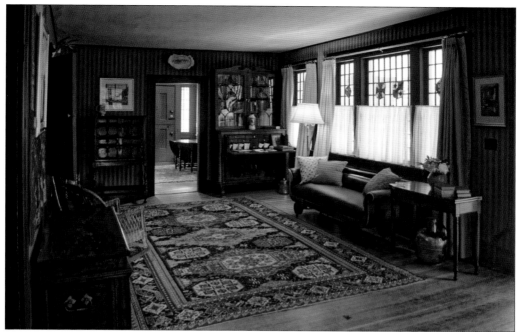

The other medallions in the living room can be seen in the photograph above looking back toward the library. Before the restoration, one of the panes above the first medallion to the right was cracked. There were many other repairs made in this large furnished space. A conservator specializing in wooden artifacts painstakingly removed layers of linseed oil and cigar smoke without stripping the original finish off of the furniture. Whenever possible, everything is reversible in case the piece must return to its original state. Other work included filling holes with epoxy, matching the tone of the wood, and stabilizing cracks.

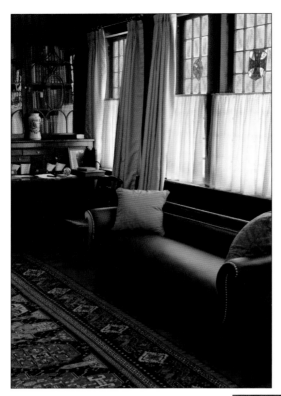

The park went to great lengths in its restoration efforts, as can be seen when this closer view is compared to Weir's c. 1890 painting *In the Living Room*. The c. 1880 mahogany secretary, seen on the left in both images, has a built-in writing desk, cupboard space, and a glass-paneled bookcase. The piece stood in that corner through three generations of artists and over 100 years of wear and tear. The National Park Service's conservation labs in West Virginia spent 186 hours repairing the leather writing tabletop, scratches, loose and broken molding, chipped corners, cracked glass, ink stains, and corroded hardware. (Below, WFNHS.)

This Victorian cast-iron clock on the mantel of "the gentleman" fireplace was also restored. The surface had a textured matte black appearance from soot and dirt, the brass elements turned a waxy dark green from corrosion, and the clock face glass and pendulum hole were covered in dirt. The clock was inspected under ultraviolet light, and solvents were tested to find the best one. The conservators spent 80 hours with an interesting bag of tricks to bring the piece back to life—a metal clay modeling tool, a bone tool, bowling alley wax, a cotton diaper, and a saliva-dampened swab. (Above, WFNHS.)

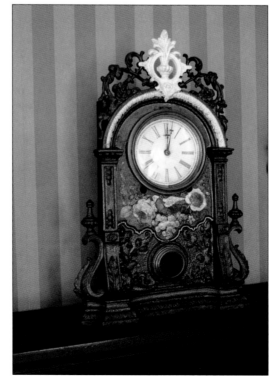

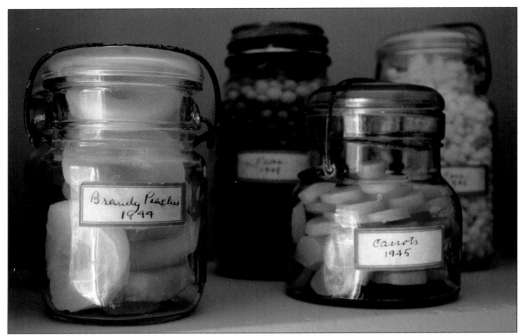

As with the living room wallpaper, another room benefitting from a discovery was this first of two pantries. Both Dorothy Weir Young and her sister Cora Weir Burlingham canned their excess vegetables and fruits. When boxes of canning jars were found in the basement, three original paper labels from 1944 had Young's handwriting. With these labels, the curatorial team at the National Park Service's Harpers Ferry Center in West Virginia was able to recreate mason jars holding faux string beans, corn, peas, carrots, and tomatoes. Lard was also kept in the pantry and was a favorite treat for Mahonri Young, which he would eat for breakfast.

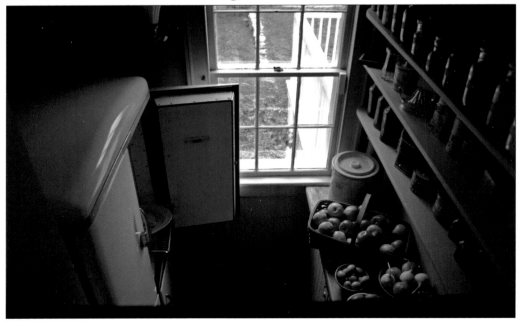

The Weirs' European acquisitions, such as the unusual Bavarian staghorn chandelier at right, also decorated the dining room. This style of light fixture, called *lüsterweibchen*, was produced from the Middle Ages to the 1900s. These carved wooden figures are mounted on antlers from the rear, where candles are placed. Conservators devoted a year to meticulously repairing cracks, removing a dense layer of soot that was obscuring the facial features and colors, recreating missing fingers, and rewiring the piece for safe electrical illumination. The original Steinway piano kept by the Weirs and Youngs in the dining room is in private hands, but the Andrews' 1902 Steinway remains as a substitute.

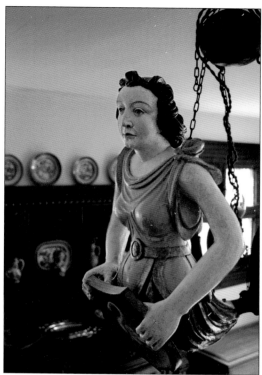

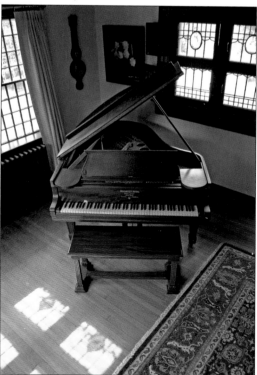

In addition to a Delft tile–framed fireplace, and more Dutch casement windows, glass medallions, and oak shutters, the dining room features a tall clock built by Roger Dunster between 1730 and 1747. The clock is made of oak with walnut veneer, has steel and brass movements, and is topped with carved gilded finials of two heralding angels and Atlas. The moon phase dial helped in planning nighttime harvesting or traveling by moonlight. After Weir's death, the clock was moved to the farm from the entrance hall of his row house on 11 East Twelfth Street in New York City.

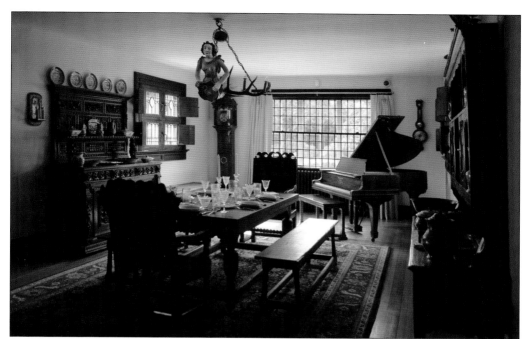

Even over a meal, Weir could draw inspiration just by looking out his dining room window. The antique glass distorts the view of his studio Impressionistically, while the panes frame individual scenes. This was not lost on Brigham Young University (BYU), which exhibited and acquired the photograph at right for its collection. After Dorothy Weir Young passed away, her husband Mahonri Young inherited the family papers and artwork. Upon his death, over 1,000 works by Weir were gifted and sold to the university founded by Mahonri's grandfather Brigham Young. As a result, BYU holds the world's largest collection of Weir's artwork.

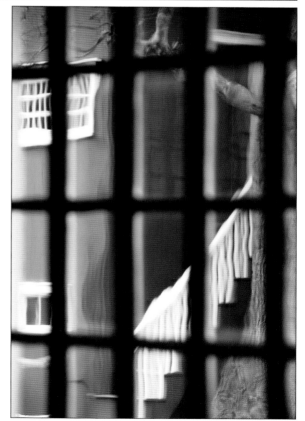

Weir's north-facing studio windows also distort. Weir learned traditional art from his father, Robert Walter Weir, and family friends such as William Cullen Bryant. The 1877 Impressionist exhibition in Paris—"worse than a Chamber of Horrors"—gave Weir a headache. By 1891, he embraced the aesthetic by freely dabbing and stroking color to create, from a distance, the illusion of flickering light, as suggested by the photograph at left and as seen below in his c. 1905 Weir Farm masterpiece, *Moonlight*. Unlike the French, however, Weir still maintained a traditional sense of realism. (Below, National Gallery of Art.)

Weir's studio is located behind his house. Its large windows stream in the consistently soft northern light so favored by painters. A letter to Weir suggests that the two large single-pane windows on top were added around 1899. It is possible that the windows were installed to increase the light after other studio windows were blocked from newer additions such as the water tower. The large oak tree, seen below, was removed in order to restore the quality of light inside the studio. The tree was blocking the windows and was not part of the original landscape.

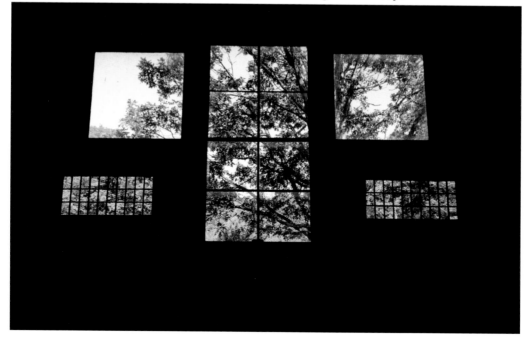

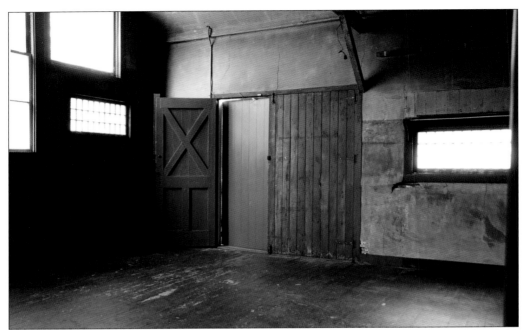

Restoration combines elements of science, research, and detective work. Conservators analyzed the composition of every dried paint drop on the floor and walls, for example, to determine whether it was Weir's paint or someone else's. The paint spots and other markings on the floor were also studied to ascertain where to place Weir's easel and furnishings. The ceiling, studded with gilt plaster stars, was also restored; an interpretive display can be seen on the studio door (below). The view in these before and after photographs is unusual, as the photographs were taken from a storage room that is not accessible to visitors.

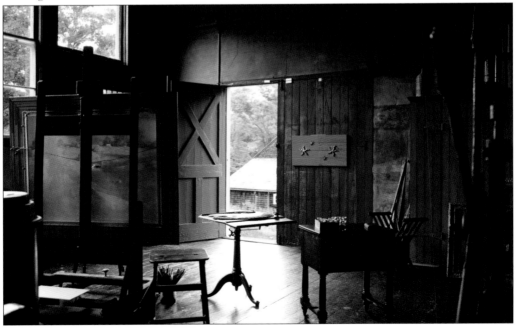

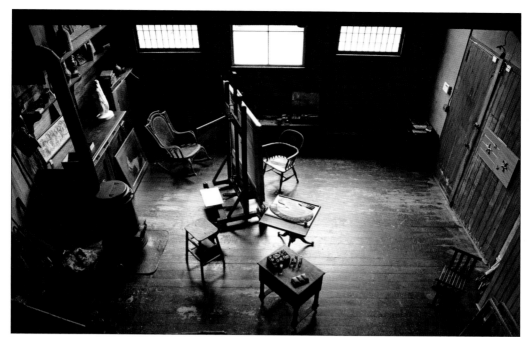

It is rare to see the studio from above. This photograph was taken from a small opening in the water tower, which is not open to the public. The workspace is virtually intact since Weir's death in 1919. On the left side, Weir could relax in a rocking chair by the warmth of a cast-iron stove with his art objects within view. Even the ceiling (right) was decorated with gilt plaster stars—each with a different shape—as if painting outdoors under the night sky. Or might Weir's imagination, given his love of fishing, have envisioned them as starfish under the sea?

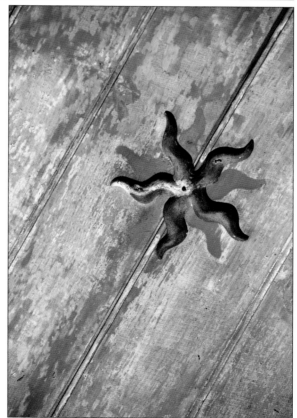

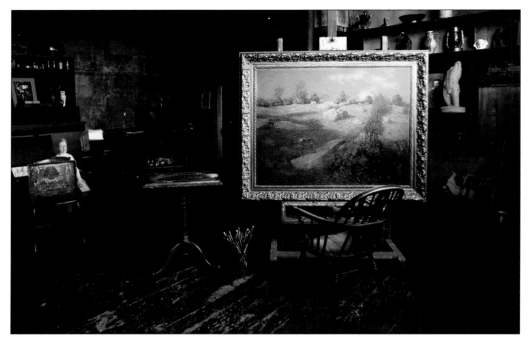

A reproduction of Weir's c. 1905 *Upland Pasture* sits on his easel. The original is at the Smithsonian American Art Museum. Authentic Weir paintings are periodically displayed, like his c. 1894 *The Laundry*, which is owned by Weir Farm Art Center and was on view in the living room in 2014. As in his other landscapes, the ground in these two paintings occupies the bottom two-thirds, and the horizons are high. The light and shadows fall upon the farm's trees, rock outcroppings, and slopes to draw the eye toward a destination along those horizons. These asymmetrical compositions, influenced by Japanese art, are distinctive of Impressionism.

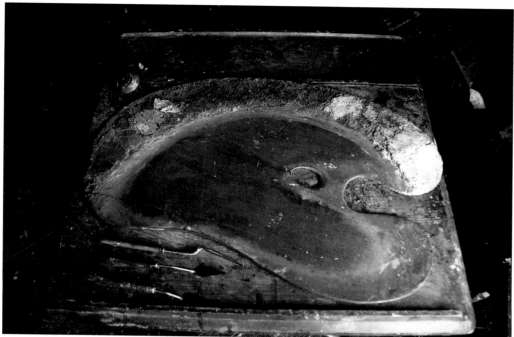

Upland Pasture and *The Laundry* also share a color range limited to greens, blues, and yellows. Yellow was such a favorite of Weir's that Tile Club members called him "Cadmium" after the vibrant new yellow pigment that was developed in the 1840s. All the members had nicknames. Photographer Napoleon Sarony was "the Hawk," perhaps because of his keen eye, while art critic William Mackay Laffan was dubbed "Cyclops" because he only had one—the other being of glass. Yellow can be seen on Weir's palette and in his gouache pigment bottles dating to around 1882–1903. These original items are on view at the studio.

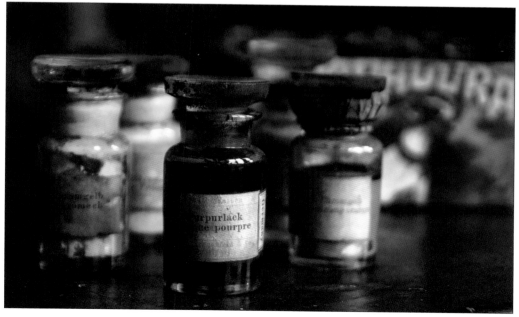

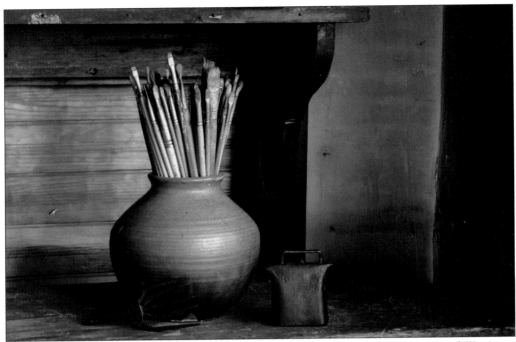

The park also has over 100 of Weir's brushes on display at the studio. His brushwork evolved from rendering detailed realism to a personal style of looser strokes and tonal atmospherics that conveyed moods. For Weir, his brushes were as inextricably linked to his love of the outdoors as was his fishing gear, which lay at the ready not far from his easel. A friend, aggravated by the chaos of Weir's fishing flies, would methodically put them back in their proper order. The organization would come undone as Weir could not help but artistically arrange them into a riot of color.

Four

THIS IS THE PLACE

Mahonri Young's studio, later used by Sperry Andrews, sits like a bookend only 30 feet from the Weir Studio, thus encompassing the three generations of artist-owners. As a tall, austere, and modern structure—and the site of Young's gritty social realist sculptures and Andrew's cubist-inspired paintings—it lies in juxtaposition to the poetic charm of Weir's studio and artistic output. The hub of shared history at the Weir House and the contrasting, yet connected, histories of the two studios are part of the marvel that is Weir Farm.

Weir died in 1919, and by 1922, the property came under the stewardship of Dorothy Weir and her stepmother, Ella Weir. After Ella's death in 1930, Dorothy inherited the property, married Mahonri Young in 1931, and transferred the Webb farm portion to her sister Cora Weir Burlingham.

The Youngs would come to spend more time living at the farm than Weir ever did. The installation of a furnace and electricity made the house habitable year-round. Victory Gardens and farm animals mitigated the food rationing and shortages of World War II. Other incentives were the landscape and farm activities that inspired many of Mahonri's sketches as well as the 1,600-square-foot studio that Dorothy had constructed so that he would have a spacious workplace to complete large-scale commissions, most notably the *This is the Place* monument for Salt Lake City. For Dorothy, the farm was a quiet environment to catalog her father's work and to write his biography.

After Dorothy's death in 1947, Mahonri spent less time at the farm. His solitude was eased when Sperry and Doris Andrews befriended him in 1952. As artists, the Andrews respected Weir's legacy and the cultural significance of the landscape. When Young died in 1957, the Andrews purchased the farm and continued to preserve the character of the property just as the Youngs did. Later, with Cora Weir Burlingham, they created a grassroots coalition that led to Weir Farm becoming a national historic site. In 2020, the US Mint will commemorate this national treasure as part of its America the Beautiful quarter series.

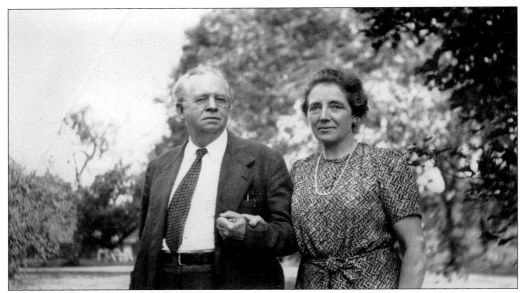

Mahonri Young's connection to the Weir Farm legacy, especially in marrying Dorothy Weir in 1931, was foreshadowed in prior encounters with her father. Young visited an exhibition of the Ten American Painters, a group formed by Weir and two friends to promote their take on Impressionism. Pictured below, they are, from left to right, (first row) Edward Simmons, W.L. Metcalf, Childe Hassam, Weir, and Robert Reid; (second row) William Merritt Chase, Frank W. Benson, Edmund C. Tarbell, T.W. Dewing, and Joseph R. DeCamp. Young later saw Weir at shows and met him twice at Young's own exhibitions. (Both, WFNHS.)

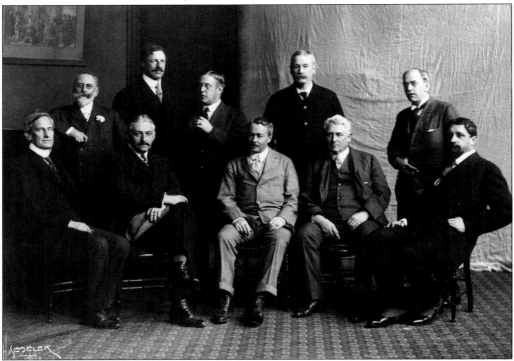

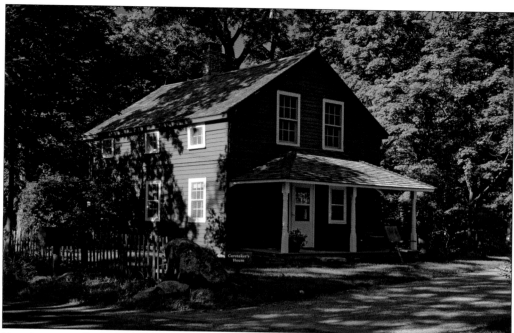

Farming generally declined, especially after World War II. The property experienced a renaissance, however, under Dorothy Weir Young and hired hands such as George Bass, a tenant farmer who lived in the Caretaker's House between 1929 and 1944 with his wife, Bessie, his mother-in-law, and 10 children. The two-story dwelling (above), built before 1861, now houses the artist-in-residence. Its origins are a mystery. Theories range from the structure being a relocated meetinghouse or barn, to a house with its cellar filled in and its roof lowered. Nearby was the garage that was converted into the artist-in-residence studio, seen below from the rear.

Although the Youngs were childless, Mahonri's grandchildren from a prior marriage, such as Charles Lay, visited. Lay fondly recalled the farm being "a child's paradise." They could wander freely, safely, and unsupervised. The barn, pictured above in winter, was frequented for the horses and cows or playing in the hay. The Secret Garden with its sundial and other ornaments was a popular spot. The trails through the woods were paths of adventure. Like Weir, the children loved walking to the pond. They could go swimming or sun themselves on the rocks. As Lay reminisced, "no one really cared where you were."

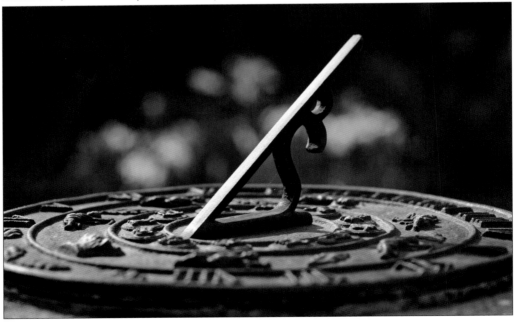

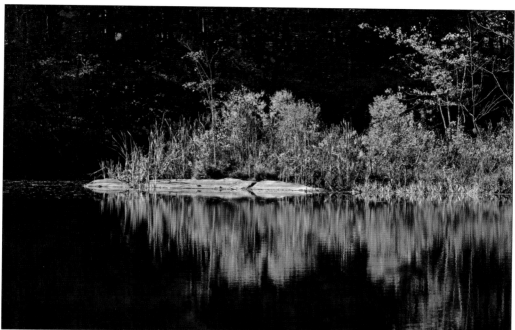

The boathouse was another fun place for the grandchildren. They fished from the dock or from a boat they took out to the pond by themselves. The boathouse was part of a gazebo that Weir referred to as the "summerhouse," which was built between 1896 and 1902. It sat in the center of a small circular island in the northeast section of the pond. By the 1930s, these structures were reduced to remnants or disappeared entirely. Since they were gone by the c. 1940 restoration period, the park did not have replicas constructed. However, the island still exists, as pictured here.

The most conspicuous change to the landscape was a new studio for Mahonri Young in 1932. It is pictured above on the left, only steps away from the Weir Studio. The studio's birth was truly a family affair. Dorothy Weir Young funded its construction from a bequest she received from her aunt Cora Baker. Oliver Lay, Mahonri's new son-in-law who recently graduated from the Columbia School of Architecture, designed the building. As can be seen in the photograph below, the studio has an expansive six-section skylight to bring in the same northern light favored by Weir.

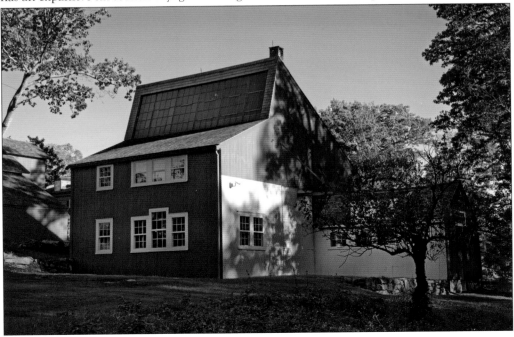

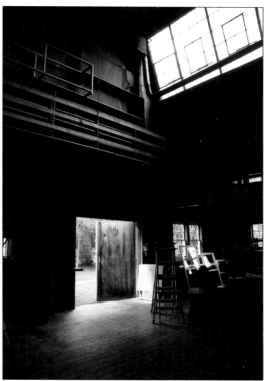

The studio is a large open space with a high ceiling to accommodate monumental sculptures. The side doorway is wide to facilitate moving large pieces in and out. The tongue-and-groove pine board flooring was varnished, but the wall treatment, consisting of tan colored fiberboard panels, and the woodwork were left unpainted and unfinished. It is possible that this no-frills approach was intended to minimize the care and maintenance of the interior while eliminating visual distractions by providing a neutral background against which to work. The photographs show an almost identical view from before and after the restoration.

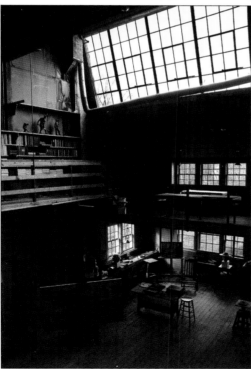

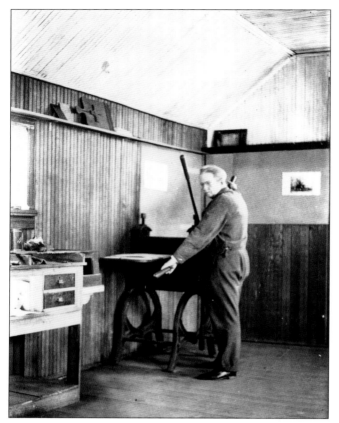

Dorothy Weir Young's oldest sister, Caro, had a one-room bindery on the farm. After establishing her own studio, the bindery was attached to Mahonri Young's new studio for use as an etching room. Sometimes, art and farming crossed paths in this space. In a December 1943 letter, Young described how a pig was slaughtered and "is lying on the floor in my etching room cut up and frozen stiff" for the making of a pork cake. The photograph at left shows Young operating the press in the etching room around 1937, and below is the restored view. (Left, WFNHS.)

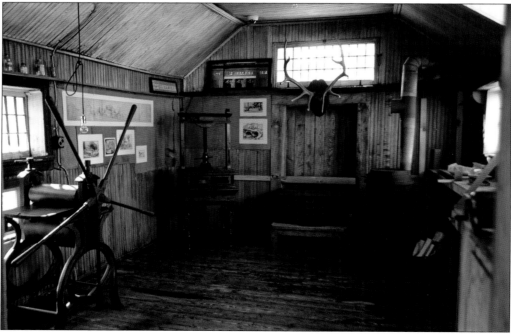

The appearance of this restored corner in the main room of the studio is remarkably close to the c. 1937 photograph of Mahonri Young in the same location, as is the pair of photographs on the previous page. The studio was heated by the cast-iron stove, which burned coal and wood. Another one was in the etching room. After Young's death, Sperry and Doris Andrews purchased the property, and continued to use the stove in the main room. Today, the stove remains as a historical artifact, but as a fire hazard, it is no longer used. (Below, WFNHS.)

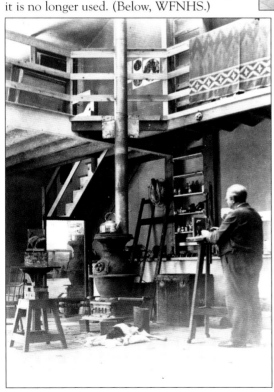

With his custom-designed studio in place, Mahonri Young was prepared to create the figures and friezes for his largest and long-awaited commission: *This is the Place*, a monumental sculpture of granite and bronze for Emigration Canyon near Salt Lake City where his grandfather had proclaimed those four words. He was awarded the commission in 1939 from the Church of Jesus Christ of Latter-day Saints and the state of Utah. The monument, 60 feet tall and 86 feet long, was dedicated in 1947, just shy of Young's 70th birthday. During this project, Young also created a pair of sculptures titled *Industry* and *Agriculture* for the 1939 New York World's Fair. (Below, WFNHS.)

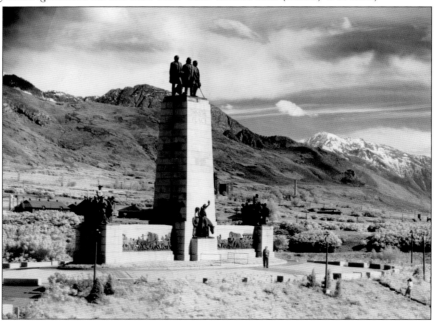

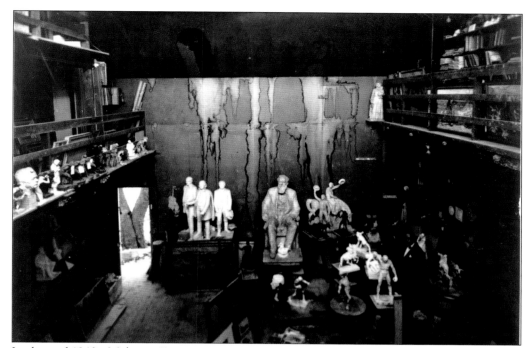

In the mid-1940s, Mahonri Young won another commission from Utah. This final major project was to produce a marble statue of a seated Brigham Young, the state's first governor. Nearly six feet tall without the pedestal, it would represent Utah in the US Capitol rotunda. A full-sized model was completed in 1947—seen above in the studio between portions of *This is the Place*—and the final piece was unveiled at the National Statuary Hall in 1950. The photograph to the right shows the same view of the studio restored. The artistically abstract water stains on the wall were preserved. (Above, WFNHS.)

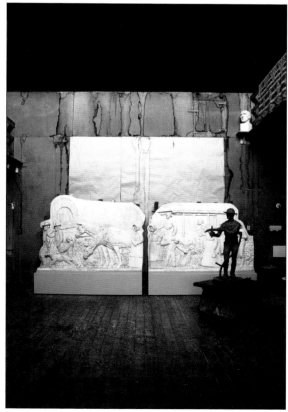

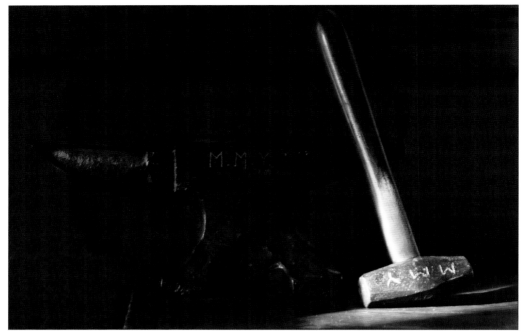

Also preserved in the studio are Mahonri Young's tools. A small hammer and anvil are on a bench in the rear of the room. These implements must have been particularly favored by Young as his initials are etched onto them. A workbench off to the side presents an intimate sense of place. There is a wooden mallet, calipers for measuring thickness and distance, and other tools housed in boxes that once held cigars and cigarettes—even in a yellow tin for crystallized ginger. Additionally, Young's original needles, cut-off wires, ribbons, and other tools for working with clay are on view.

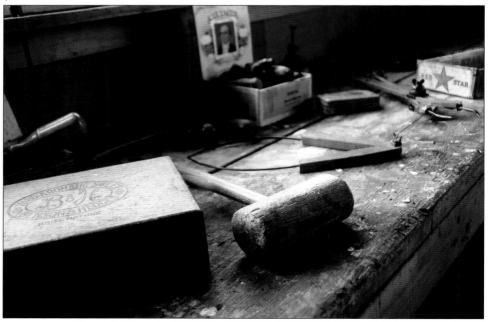

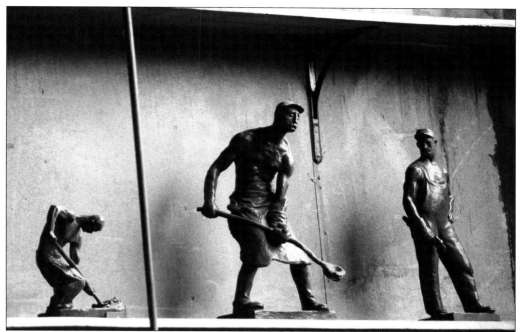

The studio also displays small casts from about 1903 that are part of Young's *Workman* series. Just as his wife had tenant farmers, Young had laborers handle the strenuous and exhausting work, particularly given his advanced age. Spero Anargyros did armature work, assembled and moved large casts, and handled tasks too menial or heavy for Young. He lived in the Caretaker's House and, in a sense, was the first artist-in-residence. He died in 2004, age 89, and was acclaimed for his own commissions. Seen below from left to right around 1947 in front of *This is the Place* figures are Hugo Ricardi, Smitty, Young, Alex Ettle, and Anargyros. (Below, Spero Anargyros.)

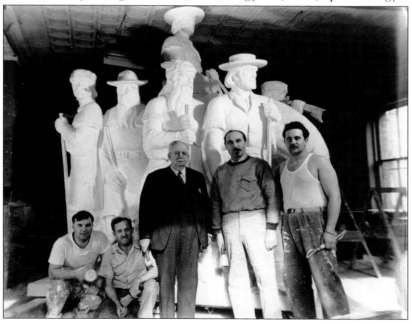

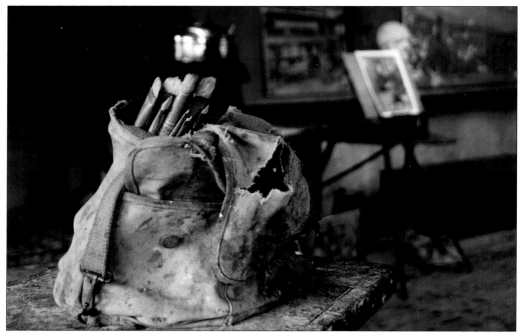

Young's high profile monuments sometimes overshadow his work in painting, watercolor, drawing, ink sketching, and printmaking. His well-worn canvas paint bag and his metal palette are on view at the studio. His depictions of prizefighters made him uniquely discussed in both arts and sports publications. Young's many drawings and sketches of the farm, together with his correspondence, were a helpful resource for the National Park Service. As a result, the 1931 to 1957 period at the farm is much better documented than the 1920 to 1930 period—after Weir's death and prior to Young's marriage to Dorothy Weir.

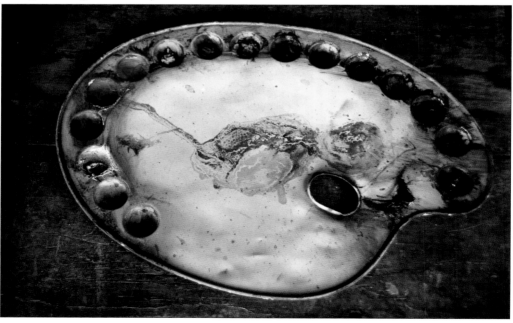

The first-floor interiors and furnishings of the Weir House remained largely unchanged as, upon marriage, Mahonri Young brought little other than his books and artworks. The original entrance hall, however, was turned into a formal library as a joint project by Cora Weir Burlingham, Charles Burlingham Sr., Dorothy Weir Young, and Mahonri Young. The year of completion, flanked by everyone's initials, was painted over the doorway into the Ryder Room. This was the only major alteration to the house during the Young tenure. Likewise, Weir's studio was left as it was, with his paintings and supplies kept there in storage.

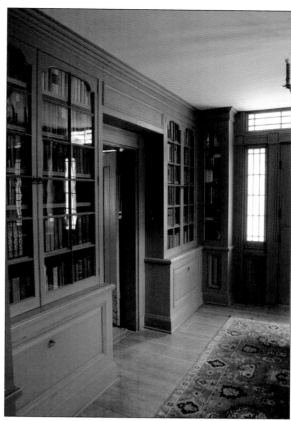

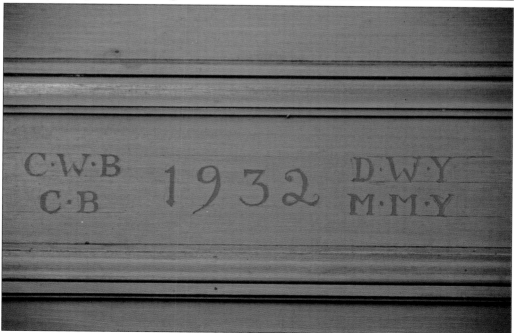

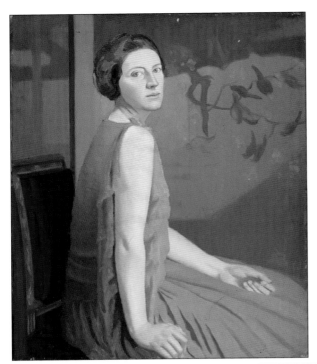

For many years, Dorothy Weir Young, pictured in a c. 1930 self-portrait at left, had been preparing research in the event someone might write a biography about her father. She contacted dealers and collectors around the nation to catalog his work and preserved the history by transcribing hundreds of family letters. Eventually, she decided to write the book herself, and the new library became her study for the endeavor. Although she died in 1947 before completing the book, the draft manuscript and research were sufficient for the posthumous publication of *The Life and Letters of J. Alden Weir* in 1960. (Left, WFNHS.)

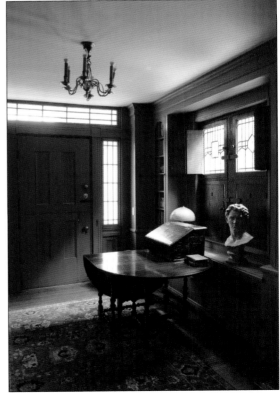

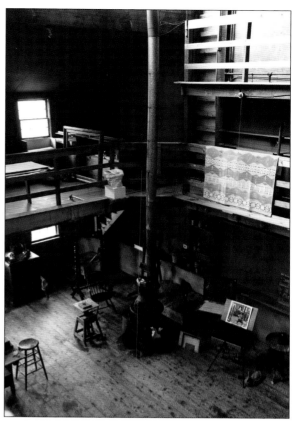

Dorothy Weir Young's death must have been particularly difficult for her husband as his first wife, Cecelia, died of breast cancer. Dorothy underwent surgery and radiation treatment in 1940 but, in 1947, her cancer returned. Without his wife, farming started winding down, and Mahonri split his time between the property and a New York City apartment. By the mid-1950s, perhaps inspired by Dorothy's foresight in documenting her father's life and work, Mahonri would climb the studio stairs to the mezzanine where he kept his books. He spent the afternoons in the clean and quiet seclusion of the "balcony" to write his memoirs.

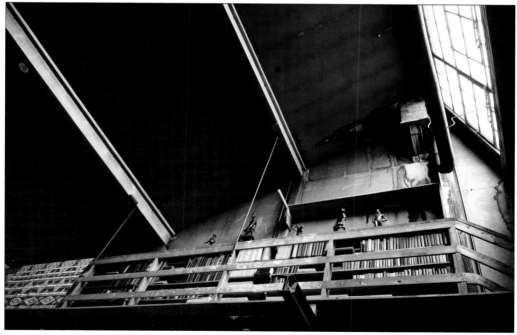

One day in 1952, Mahonri Young gruffly answered the knocking on his door by two young men who he thought wanted to fish in the pond. One of them was Sperry Andrews, an art student who had gone to a Weir exhibit. Andrews, living in nearby Ridgefield, wanted to meet Young after reading his introduction in the exhibition catalog and realizing they were neighbors. A friendship developed—that included Sperry's artist-wife, Doris, and their three children—and lasted until Young's death. Young and Andrews, pictured below around 1954, talked, looked at sketches, and painted on the grounds together. (Below, WFNHS.)

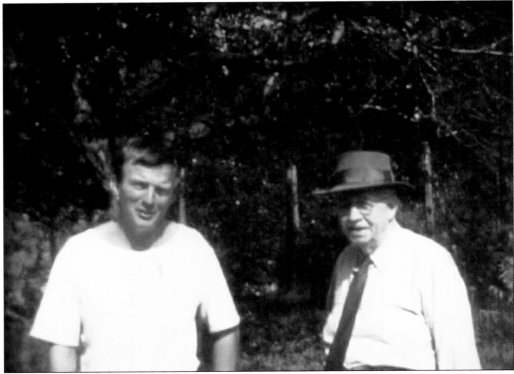

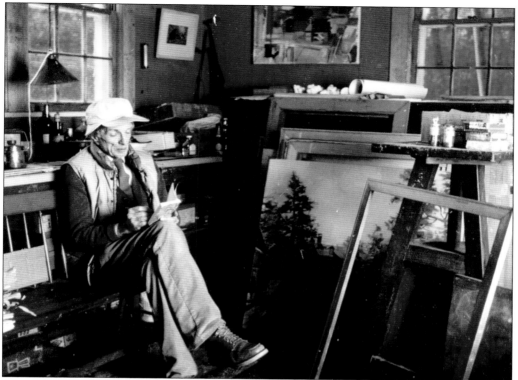

After Mahonri Young died in 1957 at age 80, Sperry and Doris Andrews purchased the property. They did no farming and kept the landscape and house as they were. Sperry, pictured above in the Young Studio in 1990, has paintings at the National Academy of Design, the New Britain Museum of American Art, and the Wadsworth Atheneum Museum of Art. Although Doris was busy with her family and the farm's preservation, she continued making ink drawings and watercolors. Beginning with Weir, through the Youngs and Andrews, art making continues at a national park that welcomes creators and appreciators of beauty from around the world. (Above, WFNHS.)

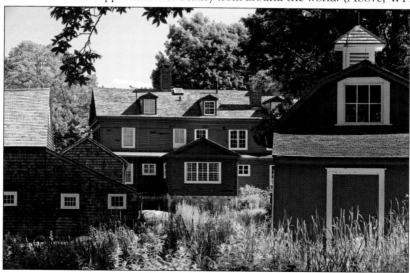

Weir Farm, Connecticut's first national park, is the second in the nation to honor an artist and the only one—out of over 400—for a painter. It is a remarkable story and trajectory for a man with a modest spirit. Like the day settling into dusk around the visitor center, Weir assessed his life with humility: "I have never had any luck except in my family." For his grandson Charles Burlingham Jr., Weir evoked "a gentler, quieter age in which family, friends and colleagues were the core of life, and sunlit fields could still be seen across a country road."

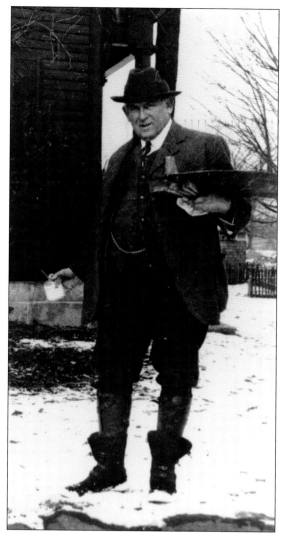

Weir, pictured at right around 1900, would have been surprised that in 2020, the US Mint's America the Beautiful quarter series will include his farm. These special collectible coins are described by the Mint as enshrining "hallowed sites." The designs under consideration intend to capture "the breathtaking beauty of America's natural landscapes that have inspired countless poets, adventurers, and artists." For Weir, the farm was an oasis from the upheavals of the Industrial Revolution. As people today wrestle with the economic, cultural, and political disruptions of the digital age, they can experience that same respite at Weir Farm National Historic Site. (Right, WFNHS; below, US Mint.)

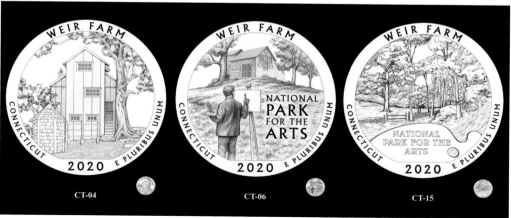

DISCOVER THOUSANDS OF LOCAL HISTORY BOOKS FEATURING MILLIONS OF VINTAGE IMAGES

Arcadia Publishing, the leading local history publisher in the United States, is committed to making history accessible and meaningful through publishing books that celebrate and preserve the heritage of America's people and places.

Find more books like this at
www.arcadiapublishing.com

Search for your hometown history, your old stomping grounds, and even your favorite sports team.